Painting Children in Oil

Painting Children in Oil

by Marcos Blahove and Joe Singer

WATSON-GUPTILL PUBLICATIONS/NEW YORK
PITMAN PUBLISHING/LONDON

To all art lovers and collectors of my paintings who made it possible for me to make a living as an artist, and to my little models who, with their patience and sincere enthusiasm, contributed so much to my success as a children's portrait painter.

Copyright © 1978 by Watson-Guptill Publications

First published 1978 in the United States and Canada by Watson-Guptill Publications, a division of Billboard Publications, Inc. 1515 Broadway, New York, N.Y. 10036

Published in Great Britain by Pitman Publishing, Ltd. 39 Parker Street, London WC2B 5PB ISBN 0-273-01228-2

Library of Congress Cataloging in Publication Data
Blahove, Marcos, 1928–
 Painting children in oil.
 Bibliography: p.
 Includes index.
 1. Children—Portraits. 2. Painting—
Technique. I. Singer, Joe, 1923– joint
author. II. Title.
ND1329.3.C45B55 1978 751.4'5 77-28845
ISBN 0-8230-3594-8

Manufactured in U.S.A.

First Printing, 1978

ACKNOWLEDGMENTS
My special thanks and acknowledgments to Susan Meyer, Donald Holden, and Joe Singer, who suggested the idea of the book and also gave me the necessary help in preparing this book.

Contents

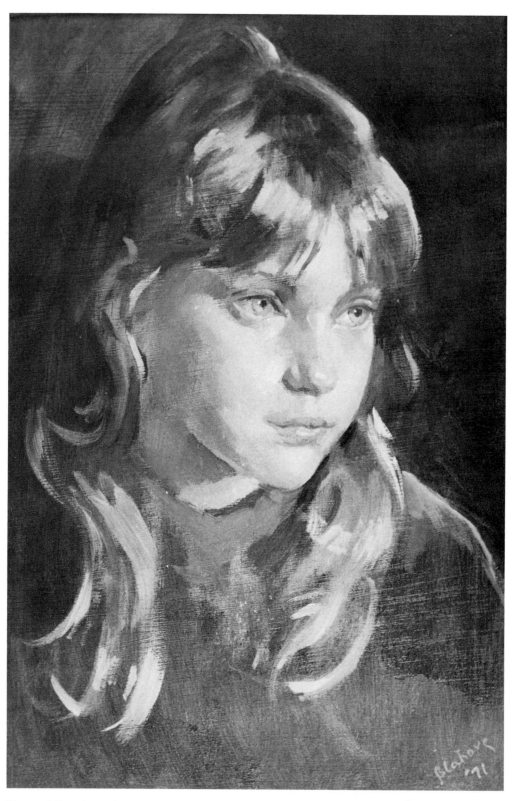

Terry. *Oil on board, 12″ x 9″ (30.5 x 22.9 cm). Collection of the artist. The subject's head and shoulders almost fill the board, and little air is allotted to other areas of the painting. This is one method I use to focus attention on the face, and in this instance, to draw the viewer's eye to the intent gaze of this rather earnest young girl. Had I wanted to make a stronger statement about her general appearance rather than about her gaze, I would have either painted her in a smaller size on the same size board, or have shown more air around her by selecting a larger board.*

Introduction

When asked what subjects he liked to paint, Claude Monet said: "I don't paint subjects, I paint His Majesty, the light." Asked which models he preferred, Pierre Auguste Renoir replied: "Those who catch the light best."

Both these Masters understood the importance of light and exploited it. They knew that even in the darkest picture, it is the brightest tones that possess the most visual importance.

The question most frequently asked me by students is: "How do I achieve likeness?" I know of many painters who, from the beginning, were taught very carefully to paint the nose, the eyes, and the mouth. This is fatal! By the time they are matured as painters, all their subjects have perfect noses, eyes, and mouths—and they all look alike.

The painter must learn to see and paint objectively. As far as the painter is concerned, the whole of the visible world is composed of areas of light and dark and of a variety of sizes, shapes, and colors. Only by looking at everything in nature in this objective manner can the painter approach each human face as something new and different that he has never seen before. By first painting hundreds of still lifes in terms of light and dark, the painter can then successfully go on to paint the human face as if it were an apple. This way, he will never fail to achieve a likeness.

In art, what matters most is charm. If your painting clearly displays tedious labor, it has failed. You may work on it a long time, but all the effort and strain should not be visible. The illusion must prevail that the work proceeded quickly, flowingly, easily.

Having made these preliminary points, I invite you to read on and explore with me how I paint children's portraits in oil.

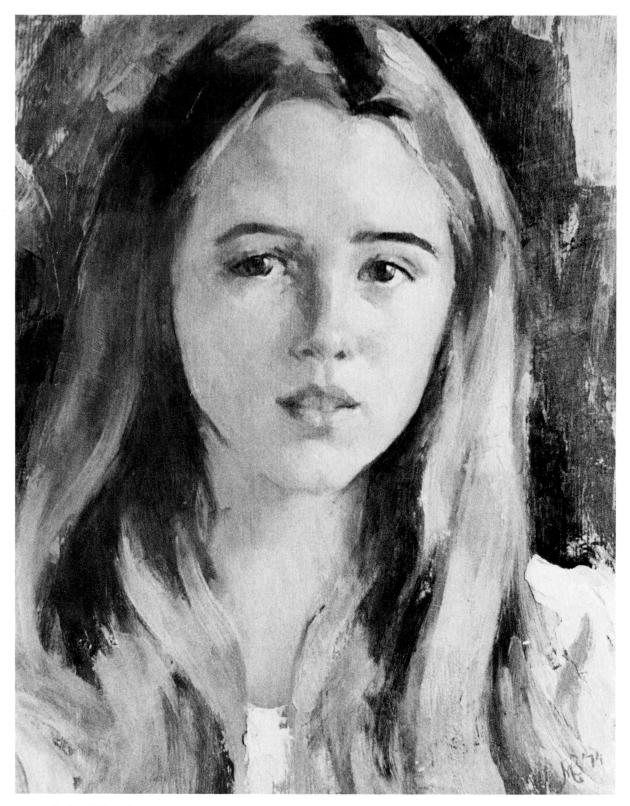

Head of a Girl. *Oil on board, 14" x 11" (35.5 x 28 cm). Collection of the artist. The full frontal view I employed in this picture was particularly appropriate for depicting the sitter's rather broad, square-jawed facial contours. Although the light struck her from the right-hand side, it was gentle enough not to create strong darks on the left or shadow side. This makes for an essentially high-key painting. It is an approach I favor, particularly in painting young people, whose essentially soft features are better served by a high tonal range.*

CHAPTER ONE

Materials and Equipment

A craftsman is only as good as his tools and materials. An ethical artist who hopes to preserve his serious work for posterity owes to himself and to those who may acquire his works the assurance that the quality of his materials is such that, in time to come, his paintings remain as fresh and as durable as the day they were painted. This is particularly true in commissioned portraiture, where the client has every reasonable expectation to retain the portrait in the family for generations. Today's superior art materials have the potential to endure for centuries. I therefore advise you to employ only those materials that are certified permanent. It is part of your responsibility to those who may wish to view your efforts in the future, just as we study and learn from the work of the artists of the past.

BRUSHES

For the type of technique I teach, I advise my students to buy a full set of filbert bristle brushes. Their flat, oval shape allows the brush to be heavily loaded with paint. Between a half dozen to a dozen of these should suffice for the bulk of the painting. I also advise you to obtain two or three big brushes of the flat or broad type, running as wide as 1½″ (38 mm), for blending.

Two additional bristle brushes I find useful are a No. 2 round brush for painting lines, and a so-called "fan blender" to soften or fuse heavily painted areas. The last brush you need is a No. 2 round sable. This is particularly suitable for small areas such as the eyes, for details, and for the signature.

KNIVES

The palette knife is one of my most useful tools. I use it for approximately fifty percent of my painting and I feel lost without it. This is a sadly neglected tool these days, which is unfortunate, in view of its extreme versatility. The Masters employed it extensively and I always insist that my students acquire at least three knives of various shapes, sizes, and degrees of flexibility.

My own favorite is a 3″ (8 cm) triangular-shaped knife. However, I suggest

you find the size and shape that best suits your individual method of working. But no matter what knives you settle on, make sure to include them among your most frequently used painting tools. A picture executed with brushes *and* knives usually displays more zest and sparkle than one done with brushes alone. In subsequent chapters, I will describe how to use the painting knife to the most benefit.

PAINTING SURFACES

Time and experience taught me that the best kinds of surfaces for painting children are either linen canvas, which is flexible, or compressed hardboard, which is rigid.

Canvas. For paintings larger than 16″ x 12″ (40.6 x 30.5 cm), I always use linen canvas. My favorites are Fredrix Kent No. 125 and Carleton No. 134, both of which are single, oil-primed canvases. Later on, I will indicate the reason I prefer single-primed canvas and the way I prepare it for painting.

Board. For pictures 12″ x 16″ (30.5 x 40.6 cm) and smaller, I buy untempered hardboard. I buy it by the sheet at the lumberyard and have it precut to specified sizes. I then prime this board myself to obtain the kind of ground I prefer.

Stretchers and keys. To stretch the canvas, I use a staple gun and conventional stretchers which are 1¾″ (27 mm) wide for paintings up to 20″ x 24″ (50.8 x 61 cm), and extra-wide, heavy-duty stretchers which are 2½″ (52 mm) wide for canvases above this size. If the canvas is really large, I use crossbars that run vertically or horizontally between the outer stretcher frame and help keep the canvas taut and the frame squarely aligned and sturdy. I use stretcher keys sparingly, and only if the canvas has, for some reason, slackened.

PALETTE OF COLORS

Over the decades I worked out a select palette of colors that serves admirably for my paintings of children. This palette was arrived at after trying, rejecting, and selecting from an extensive array of colors, and I advise my students to adopt it for their own work so that they may benefit from my long years of research. Of course, I realize that a palette of colors is a matter of personal choice, and I would never arbitrarily force it upon anybody. I can only say that it works well for me, and that it can serve as a point of departure for the less-experienced artist, who may elect to add or subtract from it or replace it with colors he finds more useful.

In any case, here it is. Note that it is separated into cool and warm colors, a division that is conducive to my method of working, which aims primarily for the interplay of cools and warms in every canvas.

Warm colors
Naples Yellow (Grumbacher Finest)
Cadmium Yellow Pale (Winsor & Newton)
Yellow Ochre Pale (Winsor & Newton)
Cadmium Orange (Winsor & Newton)
Cadmium Scarlet (Winsor & Newton)
Terra Rosa (Grumbacher Finest)
Mars Orange (Winsor & Newton)
Burnt Sienna (Winsor & Newton)

Cool colors
Cobalt Violet (Winsor & Newton)
Cerulean Blue (Winsor & Newton)
Cobalt Blue (Winsor & Newton)
Alizarin Crimson (Winsor & Newton)
Raw Umber (Winsor & Newton)
Permalba White (Weber)

I also keep several other colors on hand, such as burnt umber, which I use sparingly or for specific situations, and lead white, which I use for priming. Although I prefer to mix my own greens, I do keep a tube of chromium oxide green for occasional glazing in that color. I also advise you to buy tubes of Prussian blue and burnt umber for painting in the three-color method, which I shall say more about later in Chapter 6. In this chapter, I also will discuss some of the characteristics of each of these colors and the reasons I prefer them.

You will note the absence of black. In my earlier years, particularly during my infatuation with Goya's brooding canvases, I employed this color extensively. However, I have learned to do without it, since I now paint in a much higher key than I did previously.

PALETTE
Some artists like to hold their palette while painting. I prefer to have it resting in one spot while I move about freely. My palette is a plain wooden board, 12″ x 16″ (30.5 x 40.6 cm). I do not believe you should lay out money for an extravagant palette that does nothing to help your painting.

PAINTING ACCESSORIES
I prefer to paint under natural light; therefore I do not maintain any fancy studio lighting equipment. Nor do I keep mirrors, which many painters use ex-

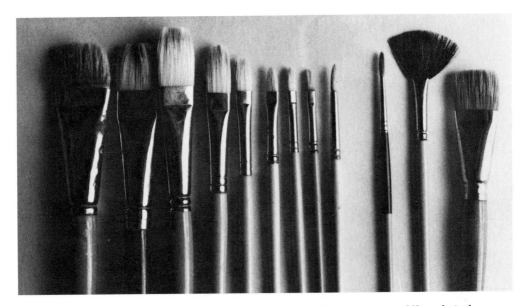

Brushes. *(From left to right) A broad bright bristle, a flat bristle, six filbert bristles, a round bristle, a round sable, a fan blender, and another broad bright bristle. The big broad and flat brushes are used basically for blending, as is the fan blender. The pointed round brushes are for lines and details. The bulk of my painting is done with the filberts.*

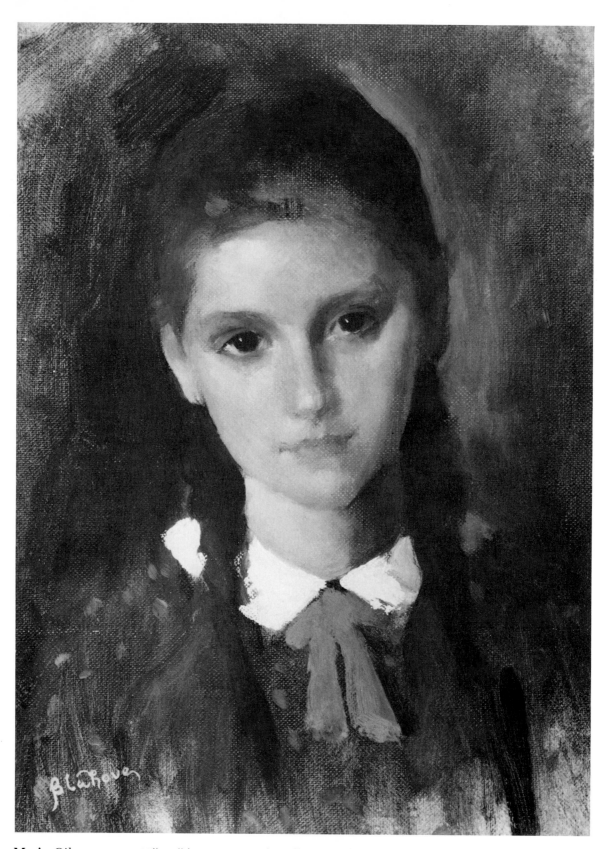

Maria. Oil on canvas, 10″ x 8″ (25.4 x 20.3 cm). Collection of Maria Tenzer. Note how softly the edges within the head are treated in comparison with those outside it, such as the light collar against the dark pigtail. The only truly dark areas within the face are the young lady's soulful, liquid eyes. But even their edges are blended softly into the whites of the eyes—which are not white at all.

tensively, particularly in portraiture. However, a very useful item for painting children—particularly those under five years of age—is a television set. This keeps them amused and comparatively quiet for hours.

You might also need such items as chalk with which to mark your easel's location between sessions, and a generous quantity of rags. Additional accessories might be pots, jars, and housepainter's brushes for sizing and priming purposes. Also, a staple gun to affix the canvas to the stretchers.

MEDIUMS

I use mediums for three purposes: for painting, for bringing up dry areas between sessions, and for glazing.

Painting medium. Because I do not want my paintings to emerge too glossy, I use only gum spirits of turpentine as a painting medium. And I use it most sparingly at that, with an occasional touch here and there when I want to render the paint a bit more liquid. Basically, I use my colors just as they come from the tube.

Retouch medium. When areas of the painting dry between sessions, artists customarily resort to a medium to bring the areas up in color, and to provide a sympathetic surface on which to resume painting. The usual medium employed for this purpose is retouch varnish, which is usually a thin solution of resin with volatile solvents added to lend it its desirable properties. I used to spray this on my paintings, until one day I recalled a substitute solution I was taught to use during my student days in Spain. I have since returned to using this mixture, which I consider superior to the usual retouch varnish put up in bottles or spray cans.

To make it, I pour equal amounts of poppyseed oil (easily obtainable in most art supply stores) and water into a bottle or jar. I shake the mixture vigorously until the solution turns milky. Then I rub it into dry or dull areas with a soft sable brush. When the water evaporates, I proceed to paint. Since this mixture tends to separate if left standing, I prepare only an amount sufficient for one application.

I cannot recommend this solution too highly over the better known commercially prepared retouch varnish. It was allegedly used by Velazquez and Monet, and with good reason. When applied to a dry or dull surface, it provides a pleasantly sympathetic surface on which to paint.

Glazing medium. I occasionally glaze my paintings. For this, I prefer a solution with a rather oily consistency. I have experimented with many glazing solutions and, after many years, have come up with a medium that is both simple to prepare and most satisfactory.

Using an ordinary kitchen measuring cup, I pour in five parts of gum spirits of turpentine to one part of damar varnish and one part of stand oil. I also add a few drops of cobalt drier to speed up the drying period. I then pour this solution into a jar or cup and proceed to glaze the areas in question with a sable brush.

Final varnish. I do not give my pictures a final varnish, since I consider this step superfluous. I believe oil paint to be durable enough to withstand the ravages of time, and I see no reason to add any finishing varnish. I realize that this contradicts the advice of most experts, but I have my own paintings as proof of my conviction. After fifteen or more years, they are as fresh and clear as ever. If they do accumulate some dirt, a very gentle cleaning with turpentine restores them to their original condition.

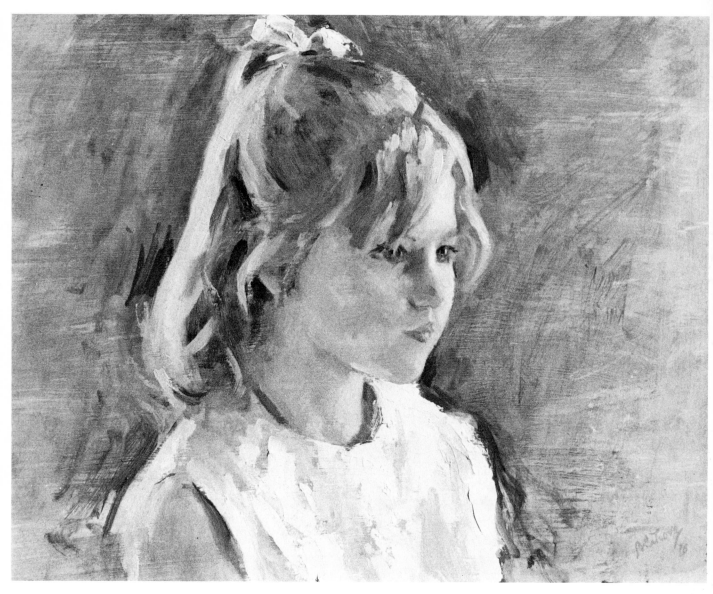

Dorothy. *Oil on panel, 14" x 18" (35.6 x 45.7 cm). Collection of the artist. The background is barely painted over and is instead left basically simple and unworked in order to show the tone of the board. The dress reveals strong accents of white laid in rather heavily with the knife. By varying the textures of various elements within a painting, you can achieve interesting effects. These surfaces would not emerge as exciting if they were rendered uniformly rough or glossy.*

DRAWING MATERIALS

For your preliminary studies you need some No. 2B Venus pencils, round natural soft charcoal sticks, and a box of Winsor & Newton watercolor cakes. You also require very smooth white paper for your pencil sketches, and rougher drawing, charcoal, or tinted paper for your tone and color studies.

STUDIO FURNISHINGS

I advise my students to keep their studios as empty as possible and avoid unnecessary clutter. However, necessity dictates certain equipment and furnishings.

Easel. I suggest you obtain a good, solid studio easel for your studio work, and a portable easel for outdoor painting and for painting on location.

The studio easel should be sturdily constructed, with a heavy base. It should be adjustable for height and able to support the largest canvases. It should also tilt forward and backward so that you may adjust its angle to whatever illumination you desire, and should be set on rollers for ease of mobility.

The best type of portable easel I have found is the so-called French easel. This folds for easy portability, yet is capable of holding all equipment for painting on location—canvas, paints, brushes, mediums, palette, and so forth.

Model stand. Because children are small and you want to see them at eye level when they are posing, you require a model stand. This should be set about 18″ (46 cm) from the floor and should be spacious enough to accommodate a good-sized armchair, if necessary. You might place a piece of rug over the floor to keep the chair from sliding. Add a set of steps to make it easier for your models to mount the stand.

Folding screen. You might also set up a folding screen behind your model for an instant background. A collection of various colored cloths and draperies also proves helpful.

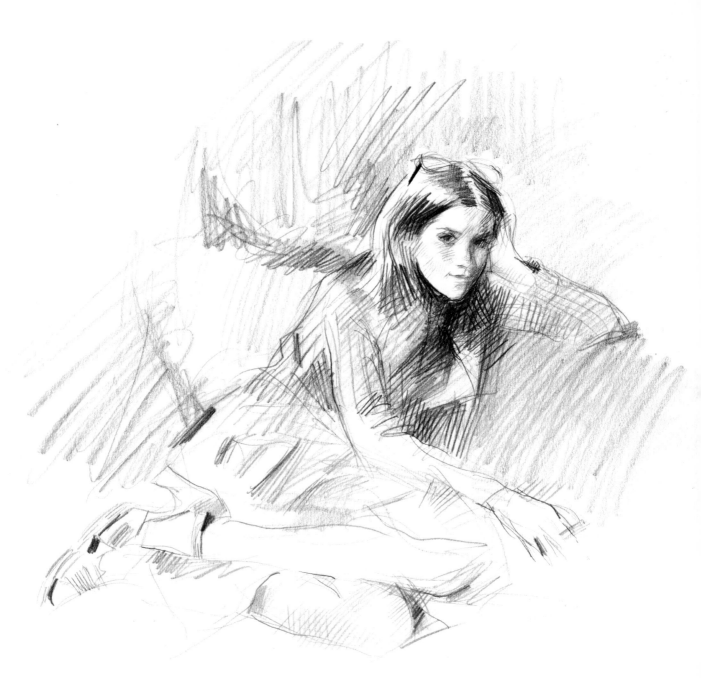

Tone Study. *Pencil on paper, approximately 10″ x 11″ (25.4 x 28 cm). This study provides me with sufficient information on my sitter so that I can proceed to the second step of the painting, without further use of the model. Although the study may appear rather sketchy, it tells me all I need to know about the tonal relationships, the sitter's pose, and her general proportions. I advise you to be accurate in your tonal studies until you have executed enough of them to be able to benefit from them even when they appear incomplete.*

Preliminary Studies

The planning and preparatory effort leading up to the actual painting is a most important aspect of the final picture. No serious artist simply plops the child down before him and goes right into the final painting. The hours spent in thinking, planning, conceptualizing, and visualizing are key factors that decide the ultimate success of your picture. I cannot stress the importance of these stages strongly enough and I urge you to keep them firmly in mind each time you contemplate a new painting.

GETTING TO KNOW THE SITTER

When the child first enters your studio, both of you are embarking upon a new experience. For the child, it is probably the first time he has been asked to pose. As for you—regardless of how many children you have painted before—you must establish this as a completely fresh and novel endeavor. This is a person you have never met, and the resulting painting must reflect *that* person only and have no bearing on all the others you have ever met or painted. If you do not remember this, you end up painting by formula—executing a picture of a child *in general* rather than of a particular, very special individual.

Since we are artists, not psychologists, the process of gaining familiarity must be confined to external characteristics only. We must ask such questions as: What are the child's dimensions, proportions, coloring, bearing, stature? What poses or attitudes does he strike and assume? There is just one way to answer these questions for artistic purposes: By picking up a pencil and sketching.

Ask him to have a seat on the sofa or on a chair placed on the model stand and, as you draw a series of small pencil line sketches, chat with your sitter and seek both to relax him and to learn something about him.

Some factors may become apparent to you. You may note that, generally speaking, girls prove better models than boys. I have found, after executing hundreds of paintings of children, that girls are more likely to be coquettish and eager to pose, while boys are more apt to be restless and squirming. You may also discover that children of both sexes below the age of five tend to be

capricious, while those over five can, after some reasoning and with some patience, be induced to sit fairly still. I have discovered, as I mentioned earlier, that a television set is a godsend in keeping my small models occupied, particularly if it is showing cartoons. You may also advise the child's parents to let him bring a favorite toy to the session.

Above all, try to put yourself into the child's place and imagine what a potentially harrowing experience this can be for him. It is almost like a visit to the doctor's office or to some other intimidating adult place. Strive, therefore, to do everything in your power to minimize the seriousness of the situation and to relax your small subject, remembering at all times that a child is a human being with excellent powers of perception and sensitivity and able to detect and resent the patronizing attitude so many grownups assume toward their juniors.

LINE SKETCHES

As I have said, begin by making five or six line sketches in pencil, each lasting perhaps five minutes or so. These first sketches are best executed on smooth, glossy paper and they can be as small or as large as is convenient. I use a 2B Venus pencil for this.

During this time, the child is assuming different poses under your direction and under various types of illumination. Approach this first step with no preconceived ideas, but let the sketches dictate the final pose.

Assuming this portrait is commissioned, no doubt the parents will offer their own suggestions. Consider each suggestion carefully, neither refuting nor accepting it dogmatically. However, make it clear from the first that you, the artist, are best qualified to make the final determination.

TONE STUDY

After executing a number of line drawings with the sitter in various poses, you may find that one pose stands out as exciting enough to pursue further. The next step, then, is a careful tone study of this pose to serve as a guide for the final painting. This might take from twenty minutes to as long as is necessary to execute an accurate study that is complete as to pose, composition, tonal relationships, background, and the proper alignment of shapes, forms, and patterns of dark and light.

Since the tone study serves as your sole source for all work performed during the second stage of the painting, it must be comprehensive enough to provide all the data you need without having the sitter actually there before you. Therefore, draw as carefully and as accurately as you can—I suggest using charcoal alone or in conjunction with pencil, and working on a paper with some texture. Finalize all decisions regarding every aspect of the picture except for color, and make sure that no problems are left unresolved, for the later stages of the painting will require your complete concentration and you must not be distracted by unanswered questions.

COLOR STUDY

In my method of instruction, the question of color in oil painting is significant, but secondary to that of value. Accordingly, you must fully resolve all the value relationships before you begin making color notations in your preliminary procedure.

Having completed the tone study to your satisfaction, and depending on how much time is left, you can now proceed to take color notes. This aids you

in the next stage of painting, where you work without a model and need all the color information you can obtain now.

I always try to visualize the completed picture during this first session. The more the painting matures and crystalizes in your mind at this time, the easier is your task as you proceed.

One of the elements to be considered at this time is the overall color scheme of the picture. Based on the child's coloring and dress, you should mentally establish the overall hue of the painting. Ask yourself: Is this a basically blue, pink, yellow, green, or violet picture?

I do not base my colors on a slavish reproduction of the original colors in the scene, but use my imagination. Therefore you also need not make color decisions based on the actual hue of the objects set before you, but may use your own creative judgment.

However, you still need to know the actual local color of the various objects—the costume, the chair or sofa, the background. Therefore, I recommend that you make a color sketch in which all but the light areas are covered with thin washes of color that approximate the actual hues of all the elements in the picture. You do not have to become involved in this exercise to the extent you did in the tonal sketch—these are merely notations to help you remember how everything actually appeared.

I use a Winsor & Newton watercolor set and a big, round, pointed brush to make this quick color study, working on any rough sketchpad paper with sufficient tooth to accept the color. If, for some reason, I lack the time to execute such a color study, I make notations in pencil where each color goes, right on the tone study or on a separate sheet of paper.

Having concluded the line sketches, the tone study, and the color study (or notations), I am ready to proceed to the final painting.

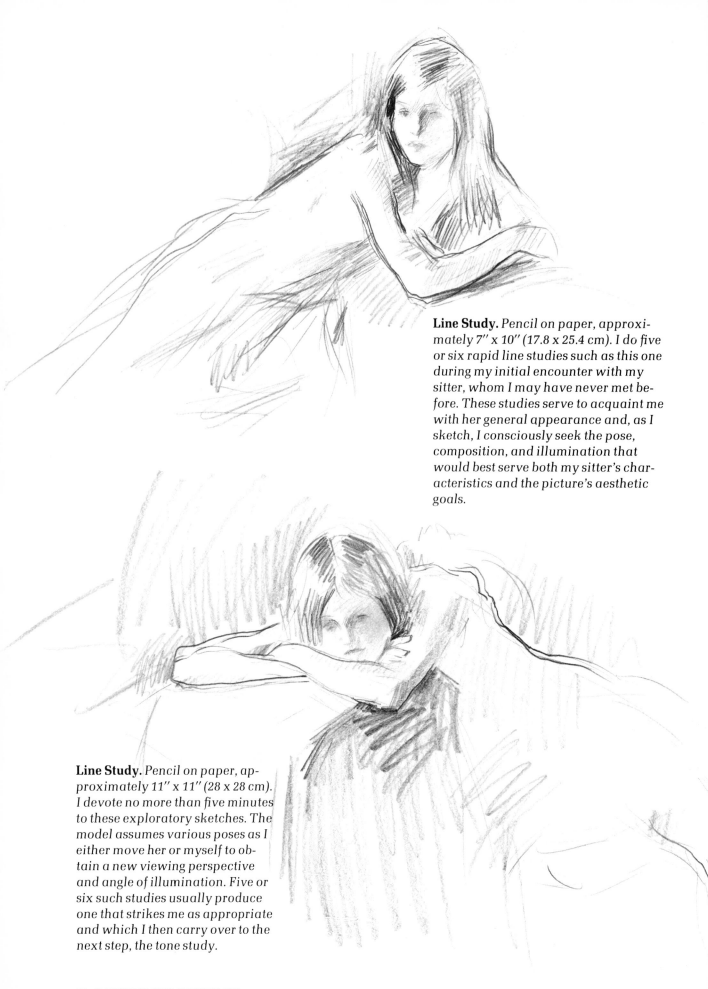

Line Study. Pencil on paper, approximately 7" x 10" (17.8 x 25.4 cm). I do five or six rapid line studies such as this one during my initial encounter with my sitter, whom I may have never met before. These studies serve to acquaint me with her general appearance and, as I sketch, I consciously seek the pose, composition, and illumination that would best serve both my sitter's characteristics and the picture's aesthetic goals.

Line Study. Pencil on paper, approximately 11" x 11" (28 x 28 cm). I devote no more than five minutes to these exploratory sketches. The model assumes various poses as I either move her or myself to obtain a new viewing perspective and angle of illumination. Five or six such studies usually produce one that strikes me as appropriate and which I then carry over to the next step, the tone study.

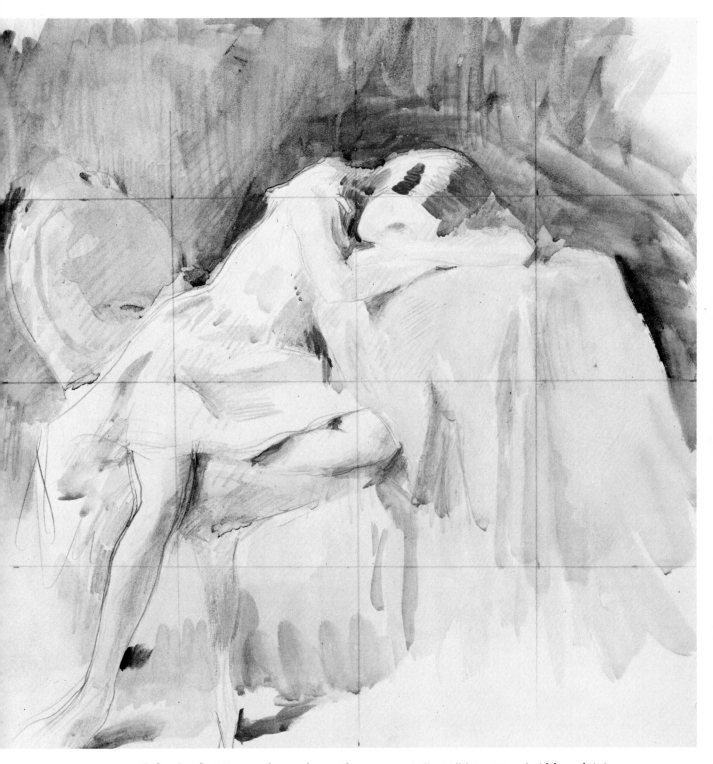

Color Study. *Watercolor and pencil on paper, 13" x 13" (33 x 33 cm). Although it is reproduced here in black and white, this study reveals how I place my color notes in the final step of my preliminary procedure. I merely lay broad, rough strokes of watercolor in their appropriate locations to remind me of the general placement of hues when I work from these studies without the model.*

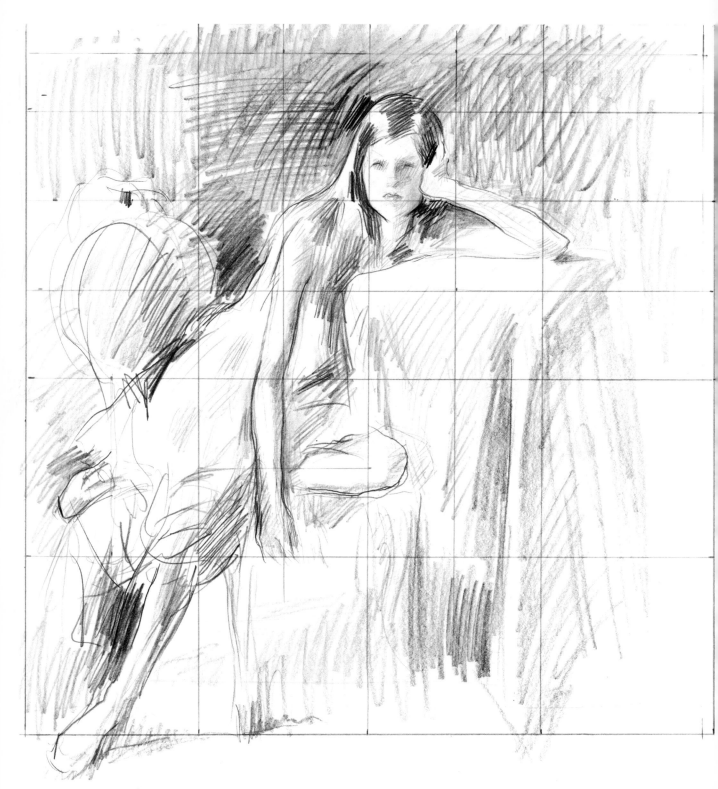

Tone Study. *Pencil on paper, 12½" x 12½" (31.8 x 31.8 cm). The grid lines act as guides in transferring the study from paper to canvas. By drawing a grid such as this on canvas (in smaller, equal, or larger proportions), I can determine where elements of the model's figure fall on equivalent squares on the canvas. This is a time-tested method used to transfer information from study to canvas or paper, where the proportions may be different.*

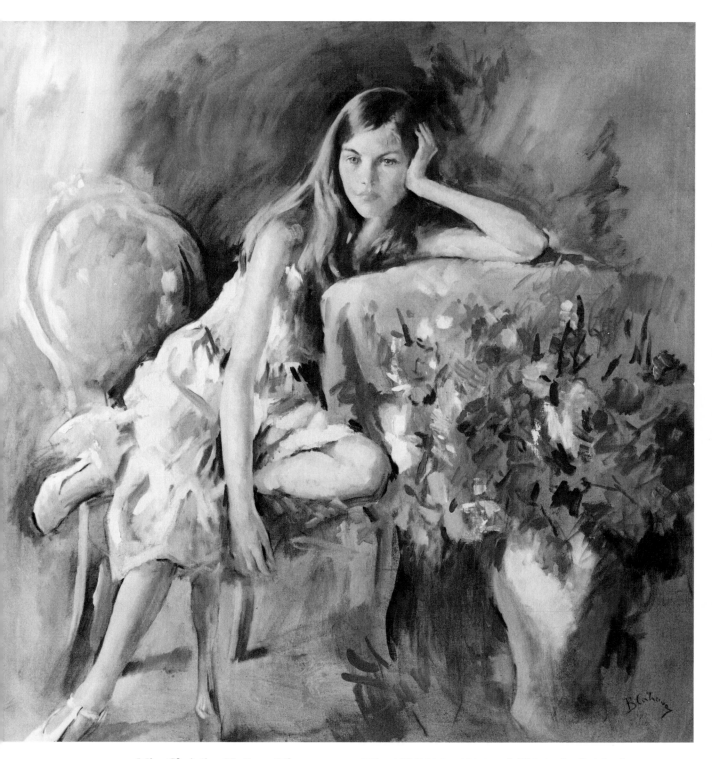

Miss Christina Hutton. *Oil on canvas, 40″ x 40″ (101.6 x 101.6 cm). This is the finished painting based on the opposite study. Note that the painting follows the sketch almost to the letter. By the time I have executed the tone study, I have visualized the painting almost completely in my mind. Elements, such as the vase of flowers, that appear in the finished painting are not essential to the original concept, so I do not necessarily include them in preliminary studies.*

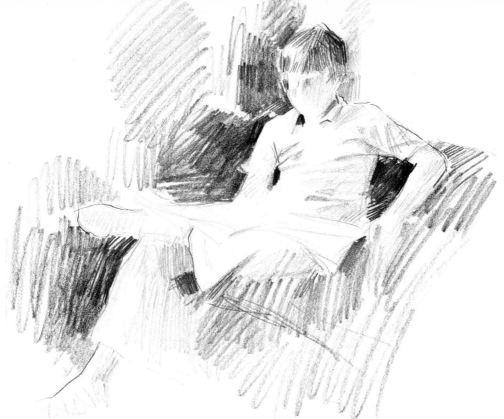

Tone Study. Pencil on paper, approximately 10½″ x 10½″ (26.7 x 26.7 cm). In this study, I was more interested in the relationships of darks to lights than in the sitter's facial characteristics. The completed painting follows this same approach. The likeness in this picture evolves from the boy's general appearance, pose, and bearing rather than from an accurate rendition of his features. Likeness is not confined to facial features exclusively.

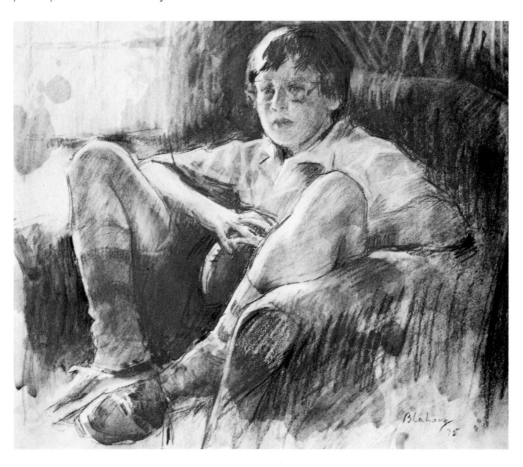

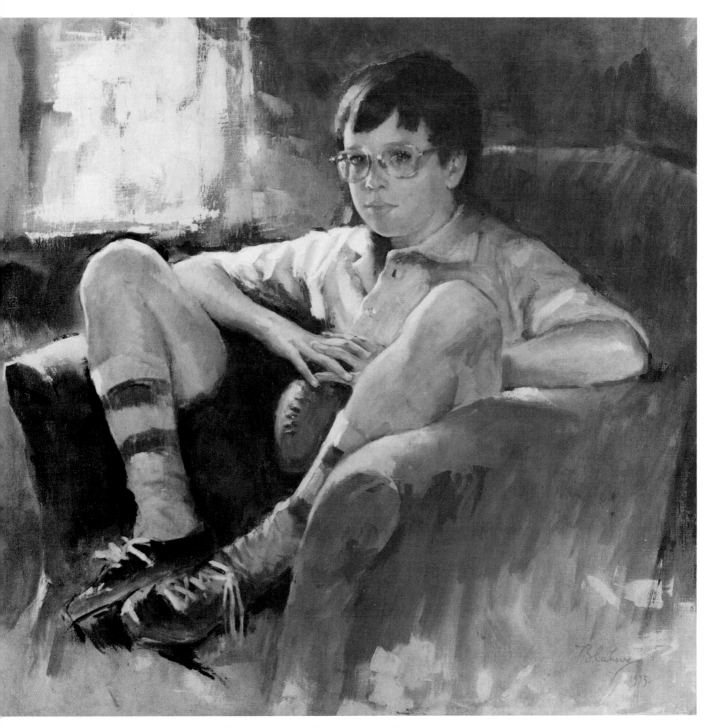

Tone and Color Study. *(Left). Charcoal and watercolor on paper. In this study of my son Mark, I went into somewhat more detail than usual. If you compare it to the finished painting on the facing page, you will note that they are similar in every respect. Armed with such a precise study, I easily could have painted the picture without Mark being present.*

Mark (Artist's Son) *(Above). Oil on canvas 32″ x 32″ (81.3 x 81.3 cm). Had I not performed my preliminary work this diligently, I might have encountered some problems from this pose, since there is a certain degree of distortion and foreshortening here. Doing my homework carefully, however, eliminated the need for concentrating on aspects of drawing in the final painting. Instead, I could focus on the actual painting procedure, which I prefer to execute swiftly and spontaneously.*

Tone Study. Pencil on paper, approximately 12½″ x 11″ (31.8 x 28 cm). All the important elements of the pose and composition are present. It is important in such a study to set down the essentials and not worry about insignificant details. For instance, I do not have to include each of the model's toes—only the action of the leg and foot. The same goes for the wrinkles in the clothing—only the major folds are necessary, not every tiny tuck and twist. Learn to look for such things as the thrust and direction of the major shapes of the form and the patterns of the darks and lights.

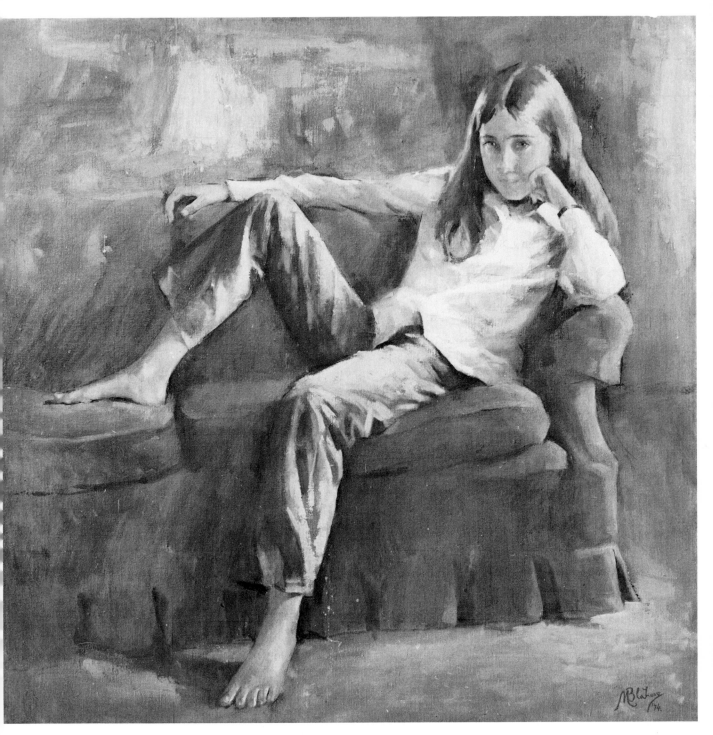

Sheila in Blue Jeans. *Oil on canvas, 38″ x 38″ (96.5 x 96.5 cm). Collection of Dr. and Mrs. Harry A. Marmion. This is the finished painting. Although this was a commissioned portrait, note the informality of the sitter's pose and costume. Could you have executed a commissioned portrait of a barefoot young lady twenty-five years ago? Not likely. Fortunately, we live in a time when the artist's range of possibilities is at its most extensive. The wise painter, however, avoids getting himself locked into exclusively formal or informal portraiture and varies his approach to suit the individual situation and sitter.*

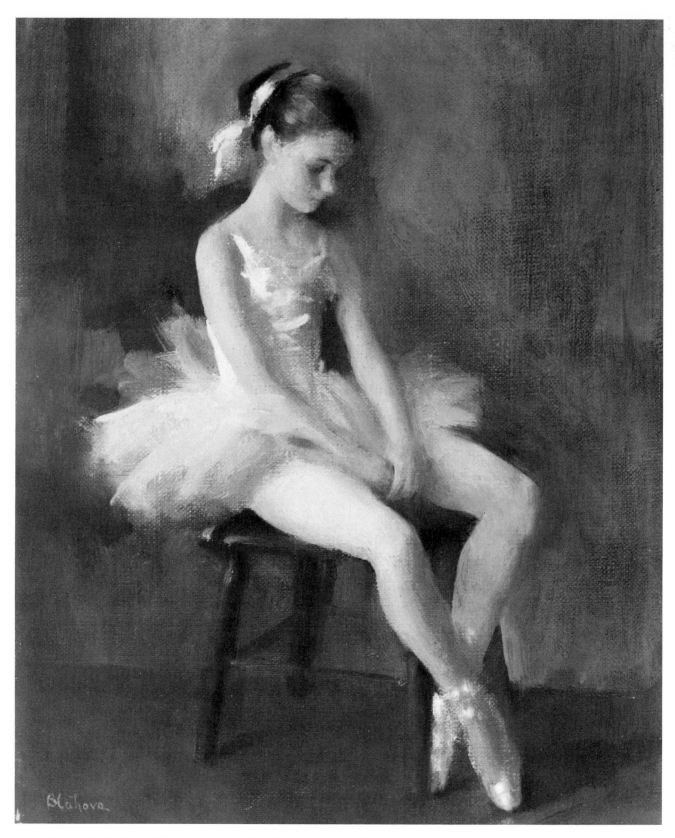

Young Ballerina. Oil on canvas, 10″ x 8″ (25.4 x 20.3 cm). I do not like to paint vigorous action poses. I find more value in depicting this young dancer in a reflective pose than in some strenuous activity. Instead of an activity, then, I employ clothing to indicate a sitter's character, interests, or pursuits. Showing my ballerina in her tutu and toe shoes is sufficient to identify her inclination.

CHAPTER THREE

Clothing and Props

There was a time when children were expected to behave like small adults, and were dressed, treated, and painted accordingly. Early portraits show them assuming rigid postures, wearing formal, uncomfortable clothing, and assuming stiff, unsmiling expressions.

Time and knowledge have taught us to regard ourselves less seriously and to adopt a more informal attitude toward life. This is reflected in every aspect of our society and, particularly, in the way we dress. Dress codes are seldom enforced in schools, and children go about in loose, comfortable clothing. It is no longer possible, as it once was, to discern the financial and social status of children from their attire, since the offspring of both the corporation president and his maid go about in equally ragged jeans.

However, some parents continue to resist the trend. If you do commissioned portraits of children, you are bound to run into the situation of the little girl with the starched dress, hair ribbon, white socks, and patent leather Mary Janes or of the little boy in shirt, tie, vest, jacket, and trousers.

SELECTING THE COSTUME

The question of how to approach the problem of children's attire does not lend itself to easy solution, since it is basically an arbitrary decision. Children look equally attractive in jeans and in party gowns.

Your natural preferences might persuade you to paint *all* children in formal or informal attire, one to the exclusion of the other. I advise you, however, not to get locked into any particular approach, since this is sure to severely limit you as an artist and incline your paintings toward a fixed, rigid look.

The best approach is to vary your sitters' costumes from formal to informal, from dark to light, from plain to patterned. This will add sparkle to your work and individuality to your paintings.

A FEW GENERAL PRINCIPLES

After having advised flexibility, I wish to point out that certain principles applying to costume do exist. They can be defined in general by answering the following questions:

Is the costume natural to the subject? After you have spent some time sketching and conversing with the child, you must try to ascertain if the costume he is to wear in the picture suits his personality. Since all of us, children included, are different, one child can feel quite at home in worn blue jeans while another may prefer a long party dress. Through close observation, you should be able to determine if your small sitter is happy with his outfit or if he was reluctantly pressed into wearing it by his parents. At this time, if the costume seems inappropriate, it is your obligation to speak out and persuade the parents to let the child change to another.

Does the costume enhance or detract from the sitter? A very busy pattern of fabric calls attention to itself and thus draws the viewer's attention away from the sitter's face. However, if the child's face is unattractive, this may be desirable. In this instance, you may deliberately wish to guide the eye to your subject's figure.

In most cases, however—especially where children are concerned—you want the face to be the center of attention in the painting. Thus, you should seriously consider a busy, complicated pattern in a garment to be a distraction.

How does the pose affect the costume? The pose you select for your sitter affects the choice of costume you want him to wear. If the child is shown sprawled on the floor reading, you probably want him to dress in shorts or in pants in order to reveal the action of the legs. Also, you would not show the child in a party dress or a formal suit—jeans would be more appropriate.

A more conventional pose calls for a more formal approach. There is nothing more appealing than a little girl all dolled up and sitting primly in a chair just a trifle too big for her.

Children engaged in play are naturally better presented in casual attire—this is normal and natural and right. But children posing with a mother would tend to look more natural in formal dress, unless you show them involved in some familiar domestic activity such as bathing, dressing, or having their hair brushed.

What does the sitter prefer to wear? It is most important and helpful to determine the sitter's clothing preferences. Every child has a favorite outfit in which he feels most comfortable, and painting him in this costume reflects the sense of assurance and ease he feels when most relaxed. Sitting for a painting is at best an uncomfortable and—at worst—a threatening experience, and anything that helps ameliorate this anxiety and tension contributes to a better picture.

In the case of a commissioned portrait, the parents' preferences must be considered as well. Although you must exercise control of the project at all

Master Smith Winborne Self *(Right). Oil on canvas, 40″ x 28″ (101.6 x 71.1 cm). Collection of Mr. and Mrs. Luther Winborne Self. In this commissioned portrait, the model is rather formally dressed in today's equivalent of what a proper young gentleman would wear to a family gathering or party. The toy dachshund he holds on the leash adds a humorous note and takes away from some of the solemnity of the painting. Block out the dog with your hand, then remove it, and note how its inclusion aids the composition of the picture. Always look for some appropriate prop—animate or inanimate—that helps the overall design.*

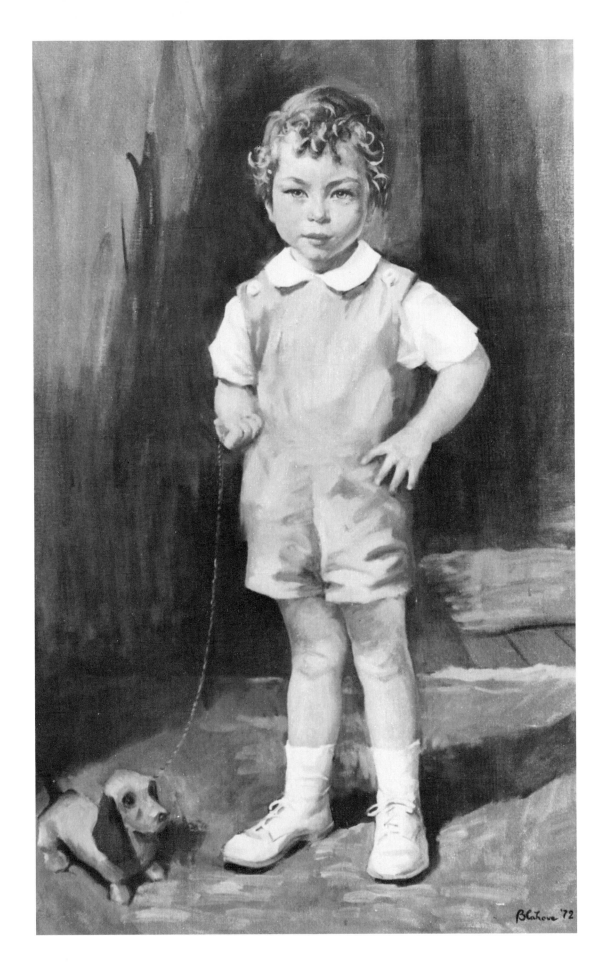

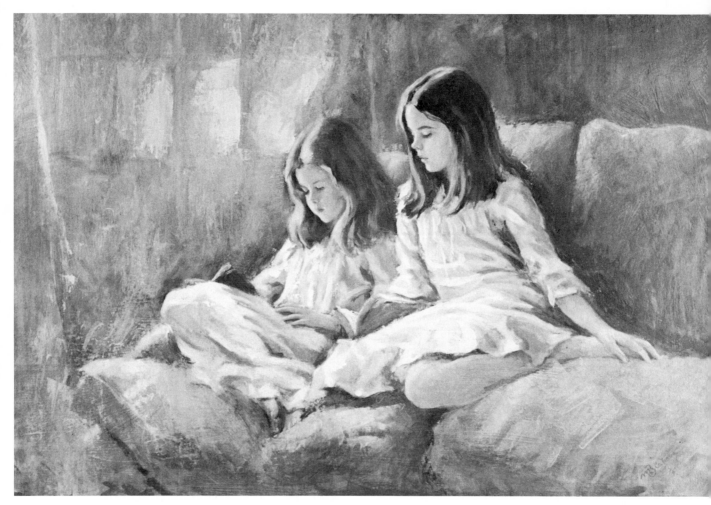

Valerie and Cecily, The St. John FitzGerald Sisters, No. 1 (Above). Oil on board, 20″ x 30″ (50.8 x 76.2 cm). Collection of Mr. and Mrs. Henry St. John FitzGerald. I painted this commissioned portrait of the two lovely sisters in the informal attire that befitted the pose—two young ladies absorbed in their reading, legs casually curled under and tucked into the floppy sofa. Compare this with the portrait of the same girls on the opposite page. Here, their eyes are turned away from us and their attention is riveted on a book. Informal pose and attire is best suited to a portrait where the subject seems unaware of our scrutiny. (The painting appears in color on page 65.)

Valerie and Cecily, The St. John FitzGerald Sisters, No. 2. (Right). Oil on canvas, 32″ x 24″ (81.3 x 61 cm). Collection of Mr. and Mrs. Henry St. John FitzGerald. In this contrasting portrait, the girls are formally dressed and sedately posed in more conventional fashion. Try to conceive of them as barefoot and dressed in leisurewear posing this way—it simply would not work. Matching the costume and pose to the goal of the picture is one of the most important tasks confronting the painter of children. The key word here must be—appropriateness.

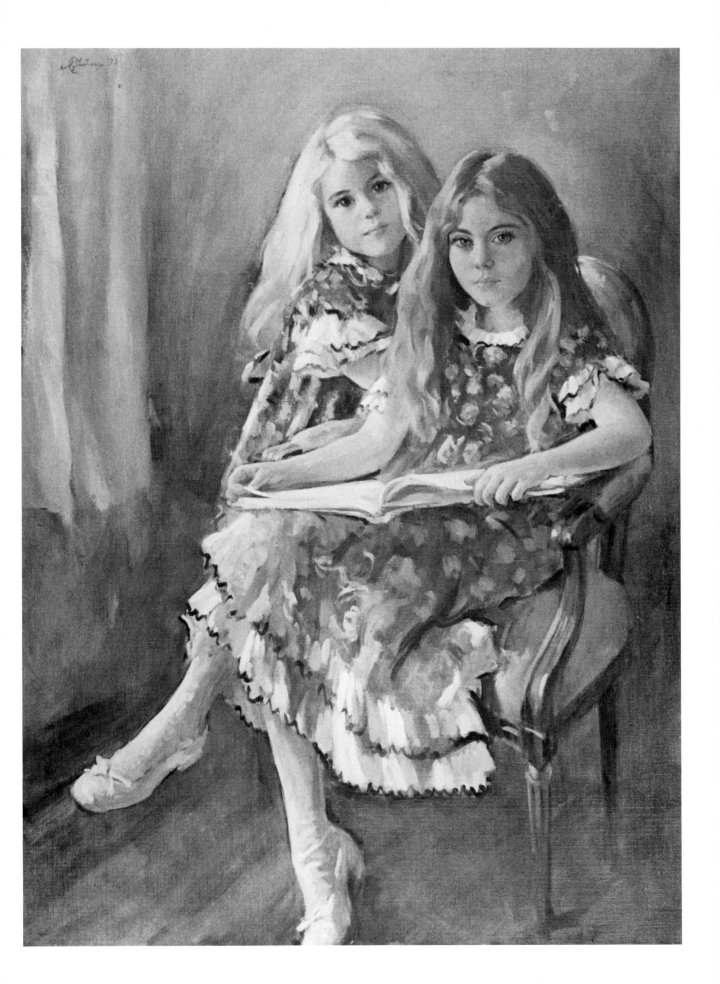

times, things go much easier and smoother if everyone's wishes are gratified. Painting a human being is, after all, a cooperative effort between artist and sitter.

Will the costume date the painting? Fashions change with the times, often rapidly. If you look at clothing of just twenty years ago, it appears comical and ludicrous. Thus, when you are choosing a costume for the painting, consider how it may appear in the future. If the costume you select is too extreme, its very individuality may take away from the quality of the painting itself by the time the child is an adult.

To avoid this, stick to clothes that are not so trendy or extreme as to be instantly identified with an era. Instead, opt for clothing that will stand the test of time. After all, girls will probably wear dresses and boys trousers in the generations to come, so do not go overboard with avant-garde designs that exceed the basic boundaries of restraint and good taste.

What tone and color in clothing is preferable? My preference is for light clothing, preferably white. I like white because it catches and reflects a wealth of colors. Actually, I can force myself to see any color I desire in white, and to paint it accordingly. Since I like to invent rather than copy color, I freely paint the shadows in white clothing in red or blue accents.

After white, I like orange, red, and yellow clothes best. If the costume leans toward the orange or red side, I compensate for its effect on the skin color of the face by making the flesh somewhat redder.

The reason I prefer light clothing is that I favor high-key painting with lots of bright color and shadows that are not too deep. I find that this works particularly well with children, whom I see as essentially happy, cheerful individuals. I do, however, try to vary my approach and occasionally paint a little boy in a dark blue sailor suit that, to me, represents a timeless costume for all generations.

SOME FAVORITE CLOTHING COMBINATIONS
Although I eternally warn my students against falling into routine and formula, I do have some general suggestions regarding costume which are intended as point of departure in matching costume to skin and hair color.

The following clothing colors are best in order of preference. For fair, pale blondes: white; pale pink; pale yellow. For brunettes, a bright red costume is attractive. For redheads, I like yellow, then white. Finally, for black-skinned children, I like white. For a vivid color note in painting girls, I like to include a bright ribbon for a striking color accent.

PROPS
Children look very natural painted with some prop that seems proper and appropriate. This might be a ball, a doll, a musical instrument, or a pet. A prop

Girl with Guitar *(Right). Oil on canvas, 20" x 16" (50.8 x 40.6 cm). Collection of the artist. In the extreme sidelighting of this study, the guitar catches the strong illumination from the window. The viewer's eye darts almost immediately to the guitar then sweeps around in a circle up the right arm, around the face, and down the left arm, back to the guitar. Lacking this prop, the picture loses much of its vitality. The fact that the sitter is active in a natural pose helps render a painting believable and charming.*

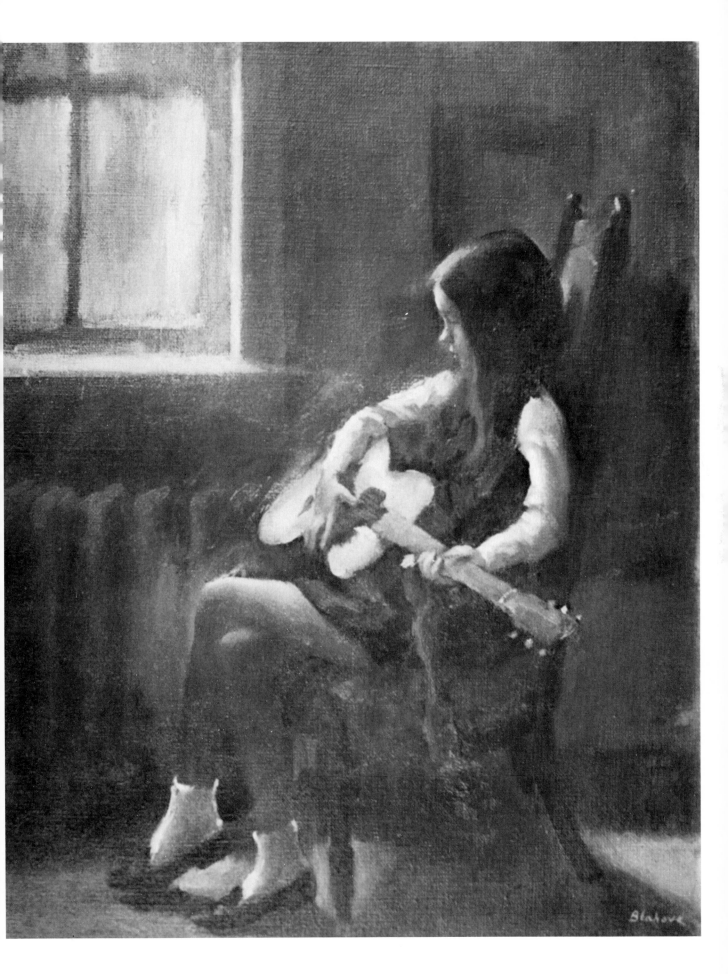

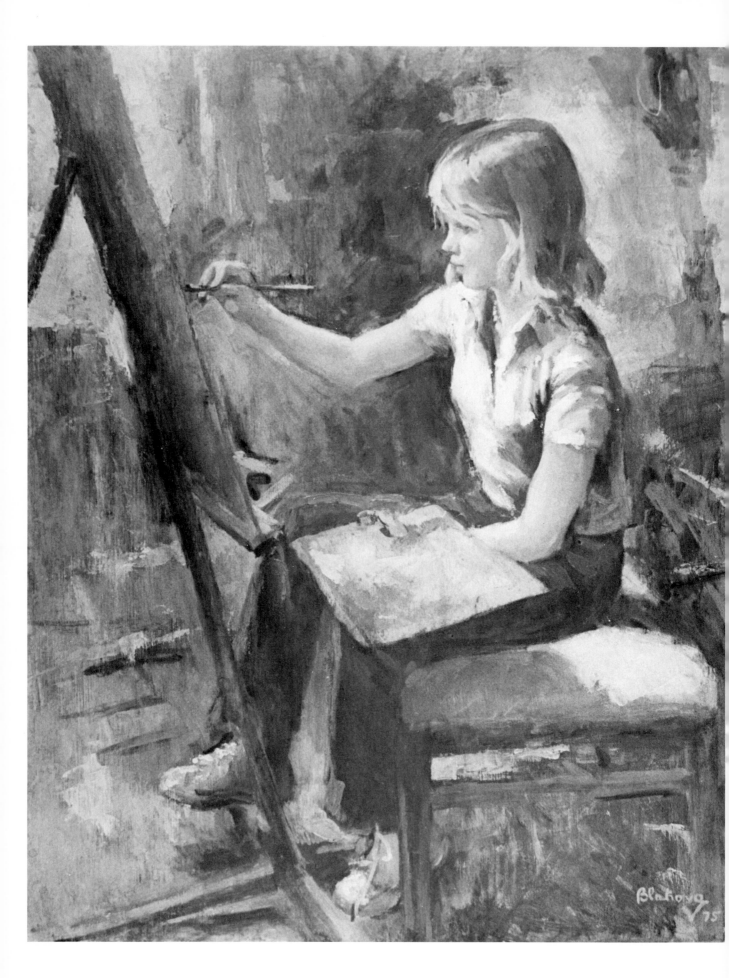

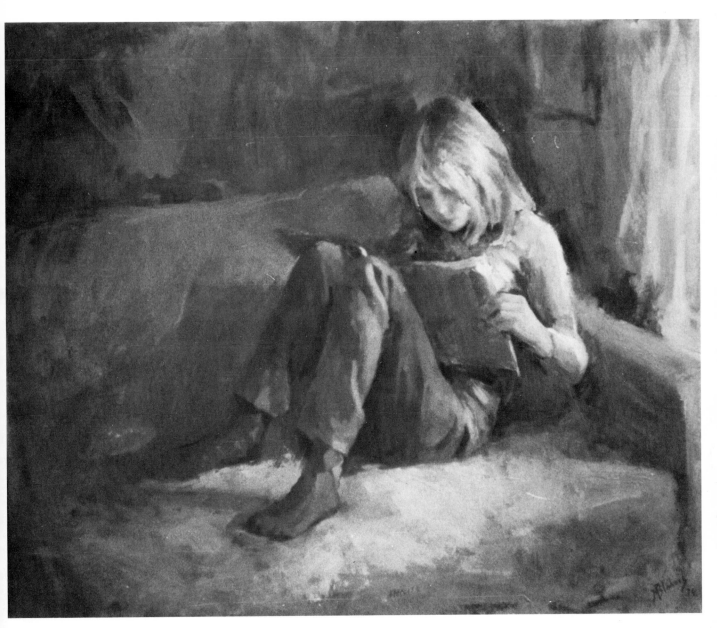

Penny Painting (Left). Oil on board, 24" x 20" (61 x 50.8 cm). Courtesy Attic Art Gallery, Greensboro, N.C. Although I do not care to show my models engaged in vigorous physical activity, I do like a pose that underlines a child's absorption in something that sincerely interests him. Rather than look for deep psychological insights, it is preferable to depict a child's individual interests, assuming these are genuine and not artistically arranged simply for the picture's sake.

Girl Reading (Above). Oil on board, 20" x 24" (50.8 x 61 cm). Collection of the artist. I return to this theme again and again since, to me, there is nothing more indicative of a child's nature than a deep absorption in reading. Adults often read because they want to learn something, or advance their career, or stay informed—but children read only for the pure pleasure of it. The book is probably the artist's best and most accessible prop for creating intriguing compositions in painting children.

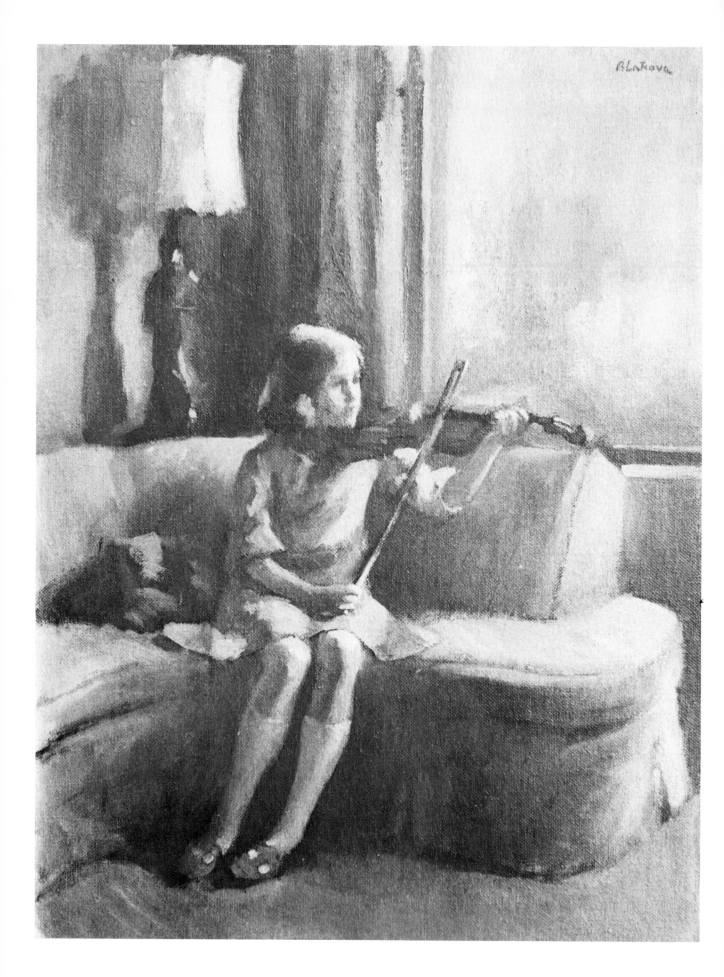

that is particularly effective is a book, which allows you to show your sitter in a thoughtful, introspective mood.

What is *not* appropriate is some unfamiliar object thrust arbitrarily into a child's hands for the purpose of gaining a desired color accent or to enhance the composition. Nothing appears so awkward in a child's hand as something that does not belong to him, something he has not fondled or touched or loved.

Children, who are guided basically by instinct, form very close attachments to inanimate objects. They may refuse to go to sleep without a well-worn, soiled rag doll or a piece of blanket. They may scream for hours if a favorite plaything is lost or abandoned. The feel, smell, and sight of a beloved object evokes in them a sense of well-being, and this immediately shows in the painting.

Whenever I can, I take advantage of this fact in my paintings. I happily add an overstuffed teddy bear, a drum, or a toy soldier to a painting. If the child has a real pet, I gladly include it. If the animal refuses to pose, I make a quick sketch and work from that, or snap a Polaroid picture of it. I know that whatever lends the child a sense of security, enhances the painting.

FURNITURE

Furniture provides both the mood and the background of the painting. Children can sprawl comfortably in a soft sofa or a large armchair. They probably curl up their legs as they read or watch television, providing you with an instantly provocative pose. Hard chairs and stools are less desirable for posing. Children like to be comfortable and they grow restless and tense when forced to sit erect for any length of time. An exception is the use of a hardbacked chair to correct a slouch.

Young Violinist. *Oil on board, 16″ x 12″ (40.6 x 30.5 cm). Courtesy Attic Art Gallery, Greensboro, N.C. I use a musical instrument as a prop at every opportunity since it helps break up the monotony of a pose and makes for a striking composition. But I would never thrust a violin into the hands of a child who is unfamiliar with it. The result would be awkward, false, and artificial. The tension would be immediately apparent in the way the child held it. Talk to your models to determine where their interests lie. This provides you with clues as to possible props you might include in a painting.*

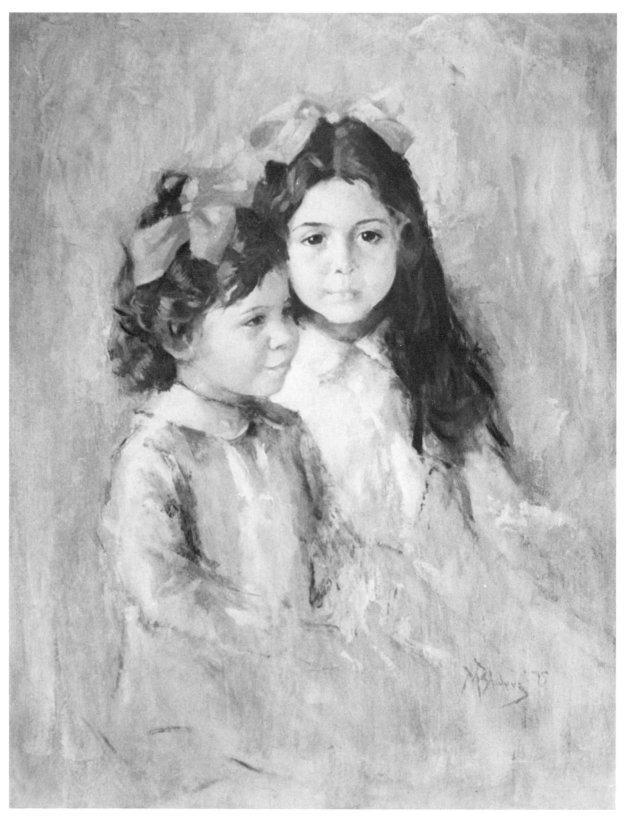

Delphine and Anouk Gazale. *Oil on board, 30″ x 24″ (76.2 x 61 cm). Collection of Dr. and Mrs. William J. Gazale. The vignette is a most versatile device in that it allows the artist considerable latitude in placing his subject within a horizontal, vertical, oval, round, or square format. In this instance, I wanted lots of air around my subjects, as well as a slight indication of their seated figures. I therefore chose a vertical board. Vignettes are effective in drawing attention to the subjects' faces.*

CHAPTER FOUR

Format

An important aspect in planning your picture is determining the size you want to paint your subject, and the dimensions and shape of the canvas itself. Great variety is possible and you must weigh a number of factors before deciding what format to use.

SIZE OF THE SUBJECT

Children may be painted lifesize, over lifesize, or under lifesize. I have successfully painted full-figure pictures no larger than 9″ x 12″ (23 x 30.5 cm). These so-called "conversation pieces" are, after all, a very desirable solution when, for one reason or another, a painting must be kept small.

I never paint children larger than life, since I consider this a generally unsuitable approach to painting human subjects. Rather, I prefer to work somewhat smaller, perhaps to three quarters of actual size, a practice advocated by da Vinci and one to which I subscribe. It seems to me that painting a head and figure slightly smaller than it actually is tends to lend verisimilitude to the painting by creating a plane between the viewer and the subject, which is how it exists in real life. After all, we do not see each other nose-to-nose but at some distance, and this illusion is enhanced by painting the subject somewhat under lifesize.

Another reason I prefer painting under lifesize is because of my desire to capture the essence of the painting rapidly, and once having achieved it, to stop as soon as possible without noodling about superfluously. This again dictates a smaller subject size, which allows for a swifter execution.

Children, with their fleeting, evanescent moods, are particularly suited to rapid, streamlined technique Other factors to be considered are a child's impatience and brief attention span, which again demand a swift execution and, therefore, a smaller subject size.

And finally, a child painted larger than life would, of necessity, appear gross, unreal, and therefore totally inappropriate. They are smaller than grownups, so why contradict nature?

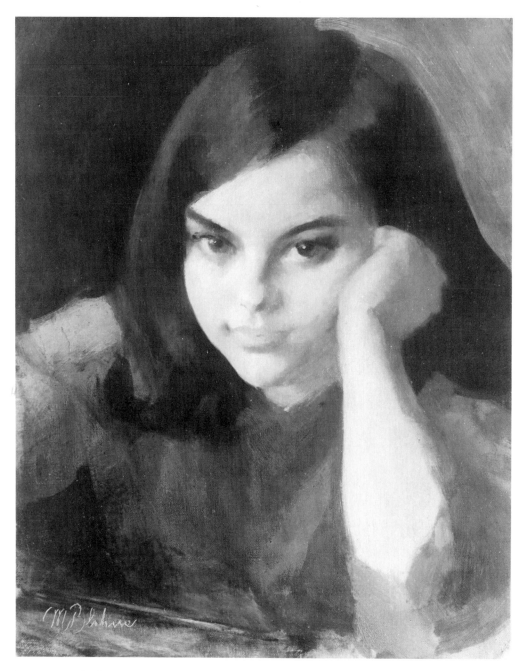

Dawn, Vertical Format. *Oil on canvas, 14" x 11" (35.6 x 28 cm). Collection of Dr. and Mrs. William J. Gazale. This winsome young lady posed for this and for the two paintings on the facing page. A comparison of these three pictures shows what can be accomplished by approaching the same model through three separate formats. In such instances, where little of the body is shown, the chief benefit lies in the variety of effects available. Simply varying the size and dimensions of your canvas prevents you from growing stale and painting picture after picture by rote and formula.*

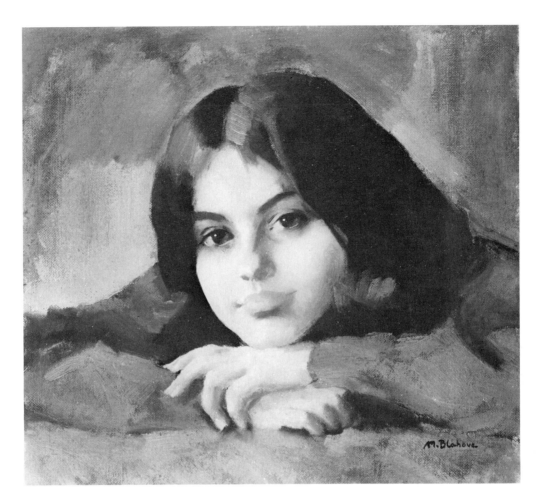

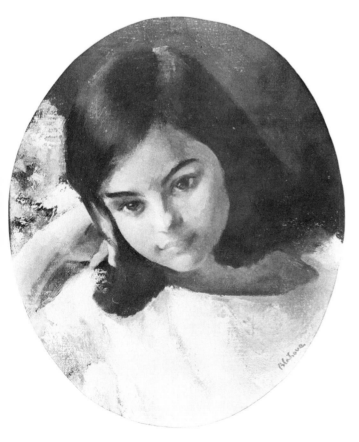

Dawn, Horizontal Format (Above). Oil on board, 10″ x 12″ (25.4 x 30.5 cm). Collection of Dr. and Mrs. William J. Gazale. This pose lends itself to a horizontal format—all the elements of the painting are set close together and the sweep of the elbows extends out to the side. The impact of this pose might be lessened if another format was adopted. I use all formats in my paintings of children, but my preference is for the square, which offers the greatest latitude for every kind of pose, lighting, and composition.

Dawn, Oval Format (Left). Oil on canvas, approximately 15″ x 13″ (38.1 x 33 cm). Collection of the artist. The oval format was used extensively in the past, usually for women or children's paintings, and often as one of a matching set of family portraits. The oval format allows the inclusion of an interesting mat or inset within a rectangular frame. This and the round (or tondo) format are particularly appropriate for a vignetted portrait.

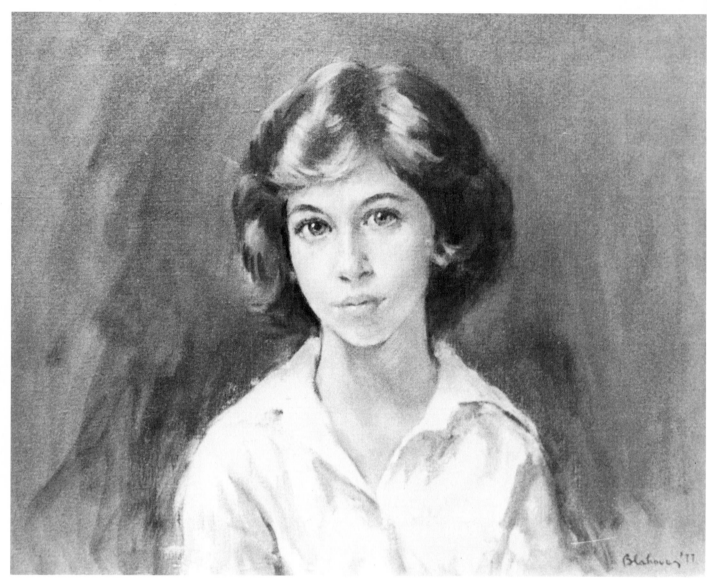

Anna Dermatas. Oil on canvas, 16" x 20" (40.6 x 50.8 cm). Collection of Mr. and Mrs. Alex Dermatas. This is an example of a basically vertical pose set within a horizontal format. It permits the inclusion of lots of air around the head and shoulders and lends a measure of scope to the painting. This is a departure from my usual approach. Normally, I would use either a vertical format, or position the subject toward one or the other side of the canvas. I did it this way basically for a change, to try something different. I believe it worked out nicely.

SIZE OF THE CANVAS

The ultimate dimensions of the picture must be decided early in the planning stages. Knowing whether you will be depicting your subject a bit or a lot under actual size will affect your decision regarding the size of the painting. In planning a portrait approximating lifesize, and not a miniature or conversation piece, you know that, if you intend to show the head only, you are naturally limited to an 8″x10″ (20.3 x 25.4 cm), 9″x12″ (23 x 30.5 cm), or at most, a 12″x16″ (30.5 x 44.6 cm) canvas, depending upon the amount of "air" you intend to include.

If the child's face is not all it should be from an artistic standpoint, you may elect to include more of the figure. At this point—if it is still intended as a lifesize painting—a larger canvas is indicated. But if you are planning to paint a conversation piece, the range of size is entirely arbitrary.

In commissioned portraiture, the size of the picture is traditionally tied to the fee the client is willing to pay, with inches often making the difference in thousands of dollars. These days, the trend generally is toward smaller pictures, whether portraits or otherwise. Modern homes and apartments have limited wall space, and galleries and collectors tend to discourage painters from the overblown, ambitious canvas that dominated the art scene in previous generations.

BACKGROUND AS RELATED TO PICTURE SIZE

The amount of background you choose to include in the painting vitally affects the size of the painting itself. Some painters like to fill the canvas with the subject; others prefer quantities of what artists call "air" around their subject's head and figure.

I like air and prefer not to crowd my canvases with the subject. Since I paint below lifesize, this keeps my pictures from expanding beyond desired proportions. I also prefer light backgrounds, and since light areas give the effect of space as compared with dark, I need less actual background area to achieve the *illusion* of size. This, too, keeps my canvases down in size.

SHAPE OF THE PICTURE

A painting may be horizontal, vertical, square, oval, or round in shape. Each of these is perfectly acceptable, and each has been employed successfully. However, several factors may enter into your decision regarding the desired shape of the painting. The first one is the pose.

Obviously, any reclining pose demands a horizontal canvas, just as a standing one calls for a vertical. But since most models are posed seated, there is usually enough latitude to choose the shape you desire.

Another factor determining the shape of the canvas is the amount of information you want to include in your picture. Obviously, if you plan to depict a broad vista behind your subject, you need width and, thus, a horizontal-shaped canvas. For vignetted portraits, a round or oval shape is desirable.

My favorite shape is the square. This allows me room in which to position my figure wherever I please and also leaves sufficient latitude as to pose, background, and the like. Although the square canvas is a rarely used format, I strongly urge you to try it for your children's paintings, since it works very nicely in most situations.

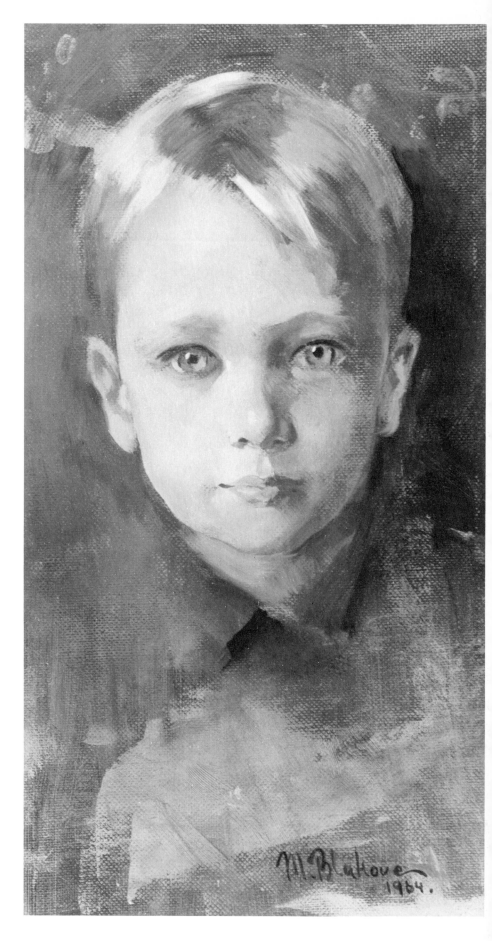

Mark, The Artist's Son.
Oil on board, 10″ x 5½″ (25.4 x 14 cm). Collection of the artist. In order to draw attention to Mark's light, clear eyes, I lighted them in such a way as to produce strong catch-lights (highlights), which rivet the viewer's gaze. I also selected a straight-on uncomplicated pose where the focus is centered on the face.

CHAPTER FIVE

Posing, Composing, and Lighting

Posing and composing the subject is a process inexorably tied to its illumination. Since, to me, painting means the representation of light striking a subject rather than simply reproducing that subject's shape, size, and color, I pose and compose my subject with the goal of obtaining the most interesting and striking effect of lights and darks bathing the form.

Since every sitter is different, arranging the lighting necessitates careful study and observation each time you begin to paint a child. You must be sure that each individual's characteristics are best presented and illuminated to capture his particular beauty and charm.

CHOOSING THE POSE

Choosing the child's pose for the painting must be classified as an instinctive process. What it actually amounts to is selecting the most artistically effective and the most flattering and representative example of that child's physical appearance. Here are some things to look for.

A particularly handsome or striking feature. If the child has unusually attractive hair, for example, you might want to pose him in such a way that the light falls on him from above, thus throwing the hair into the light area where lots of color can be depicted. Or, he might possess a particularly handsome nose, mouth, and chin, in which case you would pose him in profile, thus accentuating these alluring features. Or if he boasts a symmetrical, graceful physique, you may dress him in close-fitting clothing and show him standing, thus presenting the figure to its best advantage.

A particularly unattractive feature. In this instance, instead of accentuating a feature, you attempt to conceal or minimize it. Thus, if the child is overweight, you might dress him in loose clothing and show him curled up in a chair so that the excess bulk is less evident. If the nose is perhaps too long or the chin too weak, you may have him tilt his face upward to minimize these defects. If he is gawky or ungainly, as children often are when entering puberty, you can sit him gracefully in a straight-backed chair so that he cannot slouch. If he has

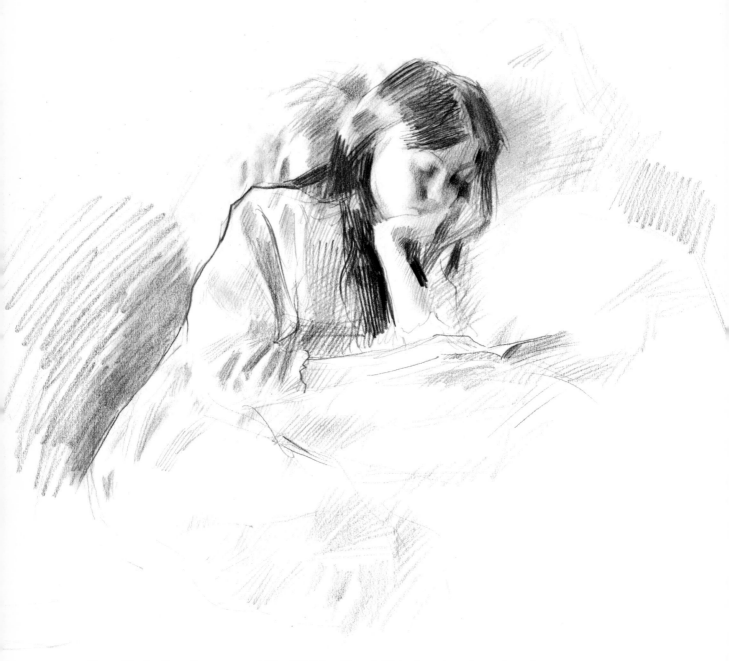

Tone Study. *Pencil on paper, 11" x 13" (28 x 33 cm). This drawing shows how I concentrated all the light on the girl's right side in such a way as to throw most of her head into shadow. Again, the book is the factor that dictated this decision. I wanted to emphasize the act of reading, not specific facial features, and so I arranged the illumination accordingly.*

pronounced acne or other skin problems, you can throw much of the face into shadow or pose him *against* the light so that the emphasis is away from the face. If he wears braces or is at a stage between baby and adult teeth, you can keep his lips closed.

Basically, this is a matter of common sense. Your goal should be to show your sitter at his very best, to accentuate his most attractive features and conceal or minimize less pleasing ones. But once you have posed, composed, and lighted him to your satisfaction, you should paint him exactly as you see him. Do not attempt to flatter by changing or idealizing what is before you. This is cheap, artificial, and unproductive. You are painting a person—warts and all— not some glorified mannequin without character and individuality.

COMPOSING THE PICTURE
Having posed the sitter to your satisfaction, you must now consider how to best frame him within the confines of the canvas. This is a most important process and one that is unfortunately too often neglected. Too many artists simply plop the figure in the center of the canvas and paint away. This is a lazy, unimaginative approach and it makes for dull, redundant, uninspired paintings.

To compose the subject with taste, flair, and imagination, you must consider these three factors: The angle of view, the amount of air, and the background. Let's consider these one at a time.

ANGLE OF VIEW
You can paint the subject looking down from above, looking up from below, or at eye level.

Looking down from above. If you paint the subject from an overhead angle, several things occur: He appears shorter, his head seems larger than it actually is, and his legs and feet, relatively smaller. The chances are the light is concentrated on the top of his head rather than on the sides of his body. Unless he is looking up, much of the lower part of the face is hidden or in shadow. There may be times when you want these things to occur, but unless this choice is deliberate, you must take into consideration some of the bizarre effects created by painting the model from above.

Looking up from below. Painting the subject from a perspective below eye-level produces the following effects: A broadening of the jaw, added height, a longer neck, a regal—possibly an aloof—air, and added bulk in the lower body and a narrowing of the shoulders. Also, if the hands are visible, they appear larger than they are in reality. Again, if these are deliberately sought effects, then painting the subject from below is a choice you have made consciously. But you should be aware of the undesirable distortions such an angle of view can produce.

Eye-level view. This is the most natural and, therefore, generally the most desirable view. Although children are shorter than most adults, and we do often see them at a downward angle, it is customary when addressing anyone—including a child—to seek an eye-level view, since it is instinctive for both men and animals to confront their fellow creatures eye-to-eye. Thus, parents often sit when speaking to a child or, if he is small enough, lift him onto their laps.

I have found that my best efforts ensue when I place the child on a model stand and face him at more-or-less eye level. I do not absolutely reject the other perspectives, but I do suggest you paint at eye level at least in the begin-

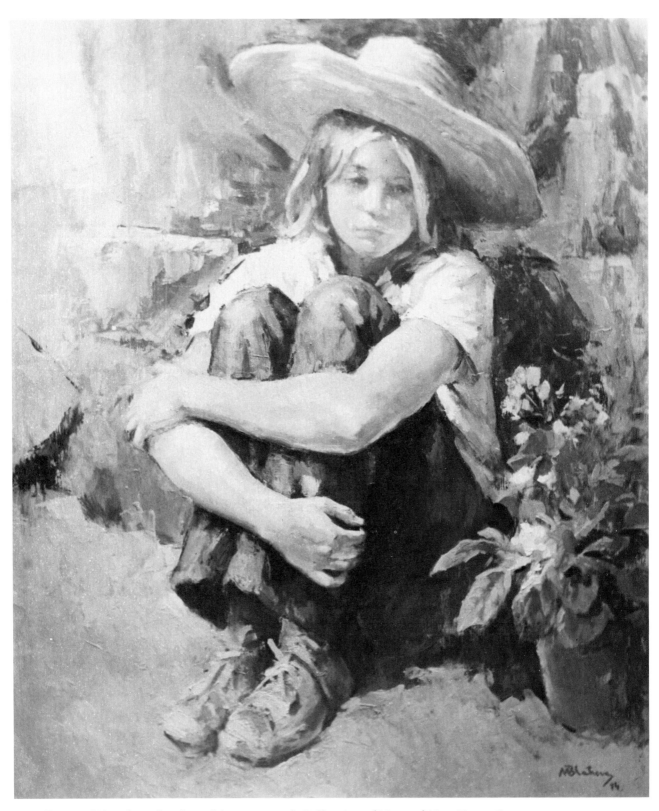

Penny. *Oil on board, 24" x 20" (61 x 50.8 cm). Collection of Mr. and Mrs. Henry St. John FitzGerald. This and the painting opposite clearly demonstrate how a similar subject and pose respond to different illuminations. Since the eye travels first to the lightest area of a painting, a change in lighting helps achieve variety in pictures. In this instance, the flowers are incidental. Our attention is directed to the sitter's right shoulder and forearm and we are less conscious of where her gaze is directed. (The painting appears in color on page 72.)*

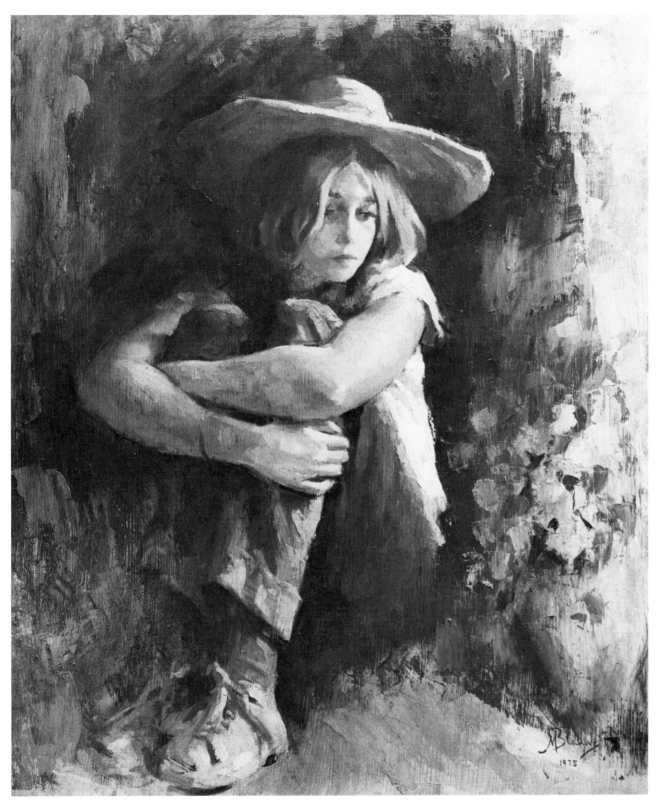

Penny (Daydreaming). *Oil on board, 24″ x 20″ (61 x 50.8 cm). Courtesy Georgetown Art Gallery, Washington, D.C. Now there is no mistaking the target of Penny's gaze. She is looking at the flowers, and we are now decidedly aware of them. By thus shifting about the angles of light, we can achieve conscious effects. It is easy to direct our viewers' eyes where we wish by the adroit use of lights and darks in the painting.*

ning, and not experiment with other, more exotic, angles until you feel confidence in your ability to execute a straight-forward picture.

AMOUNT OF AIR
The second factor affecting the composition of the painting is the amount of air or space you wish to leave around your subject. This varies from painter to painter. I prefer lots of air, since I am dedicated to a free, uncluttered effect. Some of the decision concerning the placement of a human subject within the canvas depends on whether one paints detailed backgrounds or vague, indistinct ones. I like my backgrounds unfinished—undefined extensions of color and value depicting nothing in particular and serving only to focus attention on the figure. Thus, I feel free to position my subject anywhere within the boundaries of the canvas since I am not compelled by accurate detail to keep him confined to a specific area dictated by an exact placement of furniture, furnishings, and so forth.

The more accurately and realistically the background is rendered, the more you are restricted to having to fit the subject into a logical position within the canvas, and the less latitude you have to move him around creatively and imaginatively.

BACKGROUND
The background is an integral part of the total painting and the manner in which you approach it plays an important role in the way you compose your picture.

There are two approaches to backgrounds: Setting up the background, then rendering it more-or-less accurately; or inventing and improvising a background from your imagination. Let's consider each of these approaches.

Setting up and rendering the background. This involves using screens and draperies, arranging and positioning furniture, or moving the subject around until he is posed in such a way that the existing background fulfills the artist's conception of the final picture. This is a method employed by many painters and I do not dispute it. However, it seems more cumbersome than the one I advocate—namely, inventing a background out of one's imagination.

In the former method, the artist is fairly well restricted to the actual physical conditions of his studio. There are just so many ways he can show the same chair, sofa, walls, and fireplace over and over again. A sense of sameness may begin to permeate his work. His ingenuity in showing a familiar object in a new and intriguing fashion is severely challenged and the danger of repeating himself becomes more pressing with each successive painting.

Inventing a background. I much prefer to ignore what I actually see around my subject and to create my own background from my own imagination. This affords me an infinite range of possibilities as to color and value. I am no longer a slave to what *is*, but the master of what *can be*. My background becomes an extension of the figure—often the shadow within the subject is carried right into the background with no intervening delineation.

Although I generally prefer backgrounds that are light, my rule of thumb is to keep its value range in proportion to the subject. Thus, the darkest area of my background is never darker than the darkest area within the subject, nor is the lightest area of the background lighter than the lightest area of the subject. As to color, I try to pick up and repeat the colors of the subject in the background, reflecting one into the other. To sum it up, my background is an exten-

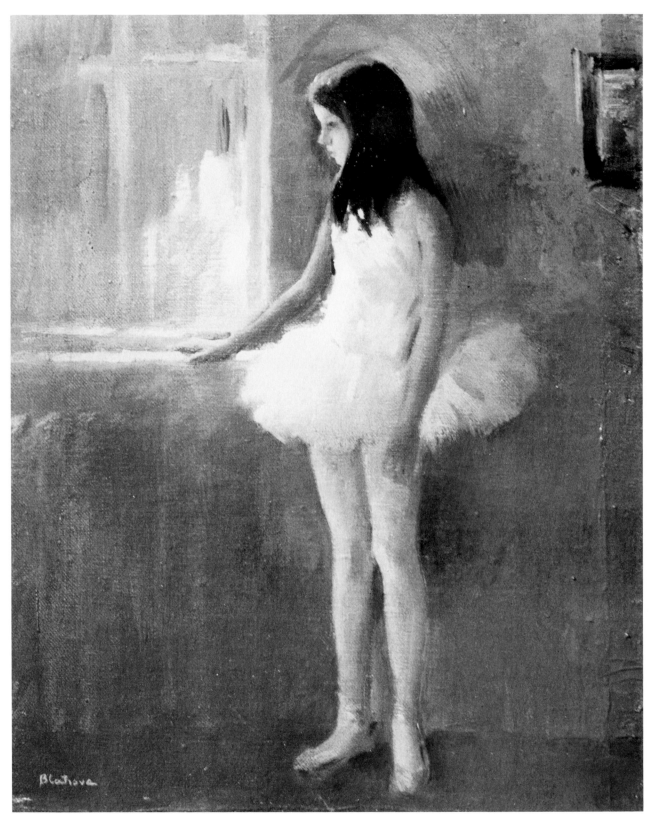

By the Window. *Oil on canvas, 9″ x 12″ (23 x 30.5 cm). Collection of the artist. The strong window illumination is matched in intensity with the white of the fabric in the light areas of the costume. Note how the tones of the background drift into the model's upper left arm where the two tones are almost equal in value. On the other hand, where the lightest areas meet the darkest ones, the sharpest edges within the painting are formed.*

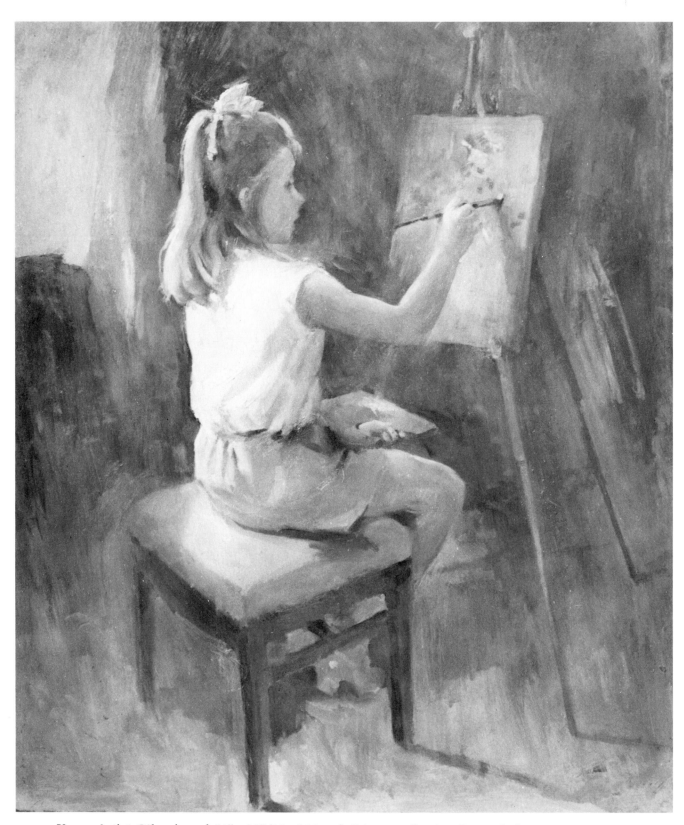

Young Artist. Oil on board, 24″ x 20″ (61 x 50.8 cm). Private collection. Instead of throwing the light on the front of the figure where the action is taking place, I focused it on her back. This serves to draw attention away from the arm, canvas, and easel. Had I wanted to stress action rather than design, I would have reversed the illumination. By deliberately manipulating the light in the painting, you can direct the viewer's eye to the area or action you want to emphasize.

sion of, rather than a startling contrast to the subject in line, value, and color.

This, to me, is essentially what constitutes the composition or design of a painting. Rather than worry about lines, curves, angles, or other such considerations, I make sure that the shapes of my lights, halftones, and darks are strategically placed and harmoniously balanced, and the composition then takes care of itself. To help assure this, I usually try to place my light areas closest to the center of the painting—which brings us to the subject of lighting.

LIGHTING

Light is what I paint—and its effect on a particular form, the subject. In the human subject, there are essentially four different angles of light in indoor painting: overhead light, left or right side light, front light, and back light.

Overhead light. This is light cast by a skylight positioned directly above the sitter. It produces startling, dramatic, deep shadows, but it seems to me counterproductive for painting the soft, often unformed features of a child. It is also not conducive for the high-key painting I espouse, so I avoid it.

Side light. Side lighting is the best for most painting situations. This kind of illumination provides a full range of lights, halftones, and darks and tends to lend roundness and a three-dimensional effect to the form. The choice of whether it should come from the left or the right side should be predicated on which side of the child's face is the more attractive—and which, in turn, should be turned toward the light.

I employ a north light, which remains steadfast throughout the day and provides a rather cool illumination. This helps bring out the colors in the sitter.

Front light. At times, I pose my sitter facing the light directly. This type of light tends to flatten the form somewhat and to lower the range of values, but you can employ it occasionally to break away from routine and to challenge your ability to depict form in less than ideal circumstances.

Back light. Beautiful effects can be gained by posing your sitter with the light directly behind him. This creates a kind of halo all around the form and makes for an unusual effect. Although the face is basically in shadow, likeness can be achieved by maintaining fidelity to the image before you, since resemblance is not confined to facial features alone but is evident in every aspect of a child's head and body.

Outdoor light. Finally, there is the outdoor illumination where the effect of sky, trees, grass, and shrubbery serves to create a multitude of lights and colors emanating from any number of angles and directions. There is much reflected light thrown back into the subject's face and figure, and the consistency of fairly controllable indoor illumination is absent. Dappled effects are frequent, and clouds and mist serve to vary the temperature and the quality of light and color greatly.

The subject can be posed in full sunlight, in partial shade, and in total shade. The ever-changing, scintillating illumination represents a real test of your ability to see, classify, and set down color. There is nothing more educational, challenging, and stimulating than painting a child's portrait outdoors. It is a most refreshing departure from persistent studio painting.

To gain full benefit from it, try painting with your canvas and palette in full sunlight. You will be amazed at some of the results of this experience once you bring the canvas inside and note the vibrancy of color you get, compared to your indoor painting.

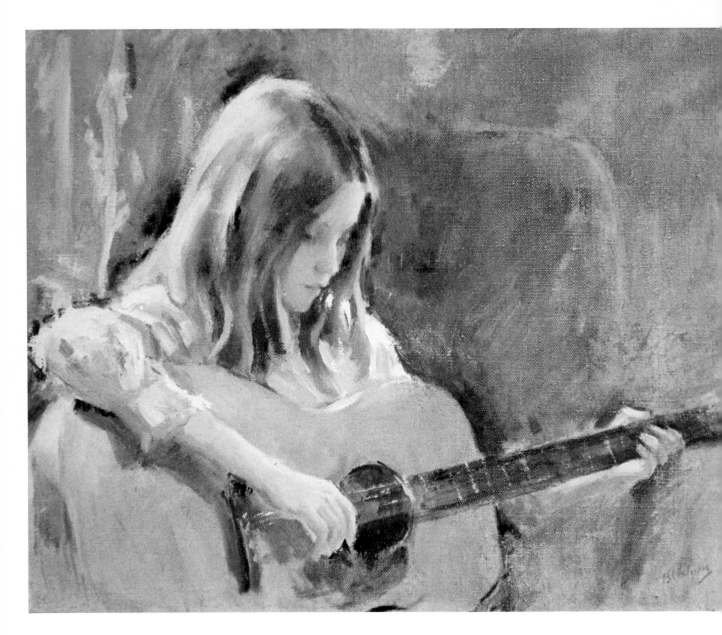

Young Guitarist. *Oil on canvas, 11″ x 14″ (28 x 35.6 cm). Courtesy Georgetown Art Gallery, Washington, D.C. The subject is positioned somewhat off center, leaving the right-hand side of the canvas basically blank. Rather than worry about lines, curves, and the like, I make sure that the patterns of my lights, halftones, and darks are strategically placed and harmoniously balanced. The composition then takes care of itself. (The finished painting appears in color on page 70.)*

CHAPTER SIX

Color

Color seems to frighten beginning artists more than any other aspect of painting. This is so because they labor under the delusion that the selection of color is an arbitrary, scientifically controlled process. Nothing could be further from the truth. Color is the most subjective factor in painting. Color is fantasy, and no one can postulate precise instructions for the instinctive, intuitive urges of another person.

This is not to say that certain principles do not apply to guide you in your color selection. But at all times it must be remembered that they are *general* principles, not dogmatic ones. The ultimate blends and combinations of color you select must, of necessity, be a product of your own taste and individual creative processes.

COLOR TEMPERATURE
Color can be divided into warms and cools.

Warm Colors	*Cool Colors*
Naples Yellow	Cobalt Violet (Light)
Cadmium Yellow Pale	Cerulean Blue
Yellow Ochre Pale	Cobalt Blue
Cadmium Orange	Alizarin Crimson
Cadmium Scarlet	Raw Umber
Terra Rosa	All Greens (ready-made or mixed)
Mars Orange	
Burnt Sienna	

From this keyboard of individual hues, the artist is now free to mix and blend his own symphony of color.

The beauty of color in painting emerges from the interplay of warm against cool color. It is only when warms are played against cools that color becomes meaningful. This interplay can be achieved by tube paints alone or by employing the tone of the canvas itself that was previously tinted to serve as a warm or cool base for subsequent color contrast.

COLOR CHARACTERISTICS

Before I proceed to suggestions regarding desirable color mixtures, I would like to say a word or two about each of the colors of my suggested palette so that you may gain some insight into their practical application in painting children.

Permalba White. This is my basic white that I use for all my painting. It is a heavy-bodied blend of zinc and titanium whites whose consistency can be controlled by the addition of medium to render it thinner and more washlike. In its normal form, straight from the tube, it lends itself admirably to all paint manipulation with brush and knife.

Naples Yellow. This is an excellent, very dense, and opaque color whose hue differs sharply from manufacturer to manufacturer. It creates brilliant mixtures for skin and hair tones.

Cadmium Yellow Pale. Since I rarely, if ever, use any color alone, this bright, sunny yellow, when mixed with Naples yellow and yellow ochre, works well for fair blonde hair. Such a yellow mixture, when mixed with cerulean and other blues, creates beautiful greens and grays.

Yellow Ochre Pale. This heavy earth color is perhaps the basic yellow found on almost every palette. I would sooner do without any color on the list than yellow ochre, which is absolutely essential for skin and hair tones.

Cadmium Orange. This is one of my favorite colors. It is somewhat brighter than Mars orange. You could obtain an approximate mixture by combining cadmium yellow and cadmium scarlet, but I like to have it on my palette because of its bright, happy character.

Cadmium Scarlet. I use this for my basic red. It is somewhat warmer than the more commonly used cadmium red light and more toward the orange side. It is closer to a vermilion, which was the basic red used before the invention of the cadmiums.

Terra Rosa. This is an earth color and is sometimes called *flesh red* or *Pozzuoli red.* With its subtle, reddish tint, it is excellent for flesh-tone mixtures.

Mars Orange. Because I so admired the reds observed in fresco paintings, I chose this dull orange for its similar tone, one that resembles the Conté sanguine tone as well. I frequently use Mars orange in my initial lay-in on the canvas and in underpainting.

Burnt Sienna. This earth color is similar in hue to Mars orange and terra rosa. I like to use all three for the subtle variety of warm reds they provide. However, burnt sienna is a much stronger color than the other two.

Cobalt Violet (Light). This is a very valuable color for toning down the warm skin accents in a fair subject. I add white and a touch of Naples yellow to gain a nice cool gray.

Cerulean Blue. I use this blue basically for cool skin accents and in combination with yellow to create green; also, to gray down a yellow that is too assertive. I never use cerulean as a straight blue. For that, I prefer cobalt blue.

Cobalt Blue. This is my basic blue. I often use it to lay in my initial sketch on canvas. I also use it for darks, combined with browns and alizarin crimson.

Alizarin Crimson. This is cool red on my palette. Mixed with white, it creates beautiful pinks. Mixed with blue and brown or green, it makes for good, deep darks.

Raw Umber. This is a gray, dull brown. With the addition of white, it creates nice grays. To produce a really striking brown, I mix it with Mars orange and burnt sienna.

BALANCING WARMS AND COOLS

I constantly stress to my students the necessity of balancing warm and cool colors to create vivid color combinations. For instance, a red made up of a warm cadmium scarlet and a cool alizarin crimson has more impact than a blend of cadmium scarlet and burnt sienna, both of which are warm. Adding a touch of a warm color to a basically cool color combination or vice versa lends a zest and sparkle that would be missing if the mixture were left all warm or all cool.

Thus, I never advise using a color just as it comes from the tube, but always in combination with one or more colors and, whenever possible, in mixture with a color or colors of the contrasting temperature—warms with cools in whatever proportion seems necessary.

USING THE TONE OF THE CANVAS

A contrast of warm and cool colors can also be achieved by letting the tone of the canvas interact with the paint. I most always tint my board or canvas a particular color. Then, when I commence a painting, I choose a canvas that contrasts with some of the colors in the subject. Thus, I might select a canvas with a terra rosa tone for an outdoor painting, then paint in lots of greens for a striking contrast.

By maintaining a number of variously toned canvases and boards in my studio, I can quickly and easily select the properly colored surface for a painting.

Although this is not an absolute, I generally prefer to begin with a warm-toned canvas and paint into it with cool accents. Greens over red, blues over yellow or orange, and violet over orange or yellow are particularly effective combinations.

COLOR-WHEEL THEORY

In order for you to better understand the warm-cool color contrast I keep advocating, let me introduce you to a simple theory which helps elaborate this concept. This is how it works. Let us assume you are looking at the object with its lightest side closest to you. Since orange is the color of the light, all objects nearest to your eye are orange. Now, those in the next nearest plane are red or yellow; those in the next nearest are violet or green; and those in the farthest plane—blue.

Applying this concept to a sitter's head, you would paint it in the following combinations:

Orange in the light		Orange in the light
Red in the lighter halftone	or	Yellow in the lighter halftone
Violet in the darker halftone		Green in the darker halftone
Blue in the shadow		Blue in the shadow

However, to obtain the most *exciting* color combination, you would do better to paint it as follows:

Orange in the light		Orange in the light
Red in the lighter halftone	or	Yellow in the lighter halftone
Green in the darker halftone		Violet in the darker halftone
Blue in the shadow		Blue in the shadow

In other words, by contrasting warms and cools you achieve a zestier, more scintillating color contrast.

This is merely a suggestion for achieving more striking color in your painting. What I stress is that you mix warms and cools. *How* you go about this is up to you. You could, for instance, reverse this wheel and paint your lights cool and your shadows warm, for there are no laws in art prohibiting *anything*. But do remember to include warms and cools in every painting if you want it to sing with vibrant, exciting color.

LEARNING ABOUT COLOR

Since I stress the knowledge of values to my students as the main aspect of painting, I tie the knowledge of color to this tonal process so that the two become an integral part of the artist's total concept of painting. My method of introducing students to color, therefore, is by having them make a grisaille. (In its traditional sense, *grisaille* meant any underpainting done in grays, or various shades of black and white. However, I use the term more loosely to mean an underpainting in light and dark values of a single hue; that is, a monochrome underpainting.)

The grisaille underpainting method entails the following procedure: Squeeze a generous amount—perhaps a quarter of a tube—of white paint into the middle of the palette. Squeeze an equal amount of Prussian blue on the right-hand side of the palette and the same amount of burnt umber on the left. (These latter two colors are not on the suggested palette, but you might consider them extras.) Now add a small touch of the umber to a large quantity of white to produce a *warm* grisaille. Then add a small touch of the Prussian blue to a large quantity of white to produce a *cool* grisaille. You now have a three-color palette—white, warm grisaille, and cool grisaille.

For the next three or four months, paint subject after subject in these three colors only, seeking to combine accurate value with approximate hue. Once you have gained some knowledge of how the balance of warms and cools behaves under actual painting conditions, you can add cadmium scarlet to the palette and work with a four-color palette. Then add a cool color, such as cobalt blue, and work with five colors. By this time, you should have learned to achieve a fairly good tonal range in your studies and you are ready to proceed to full-color painting. One thing you will have learned, and this is probably the most important thing about painting I could teach you—*if the values are right, the color is right.*

By simply studying the subject, determining where its warm and cool areas appear, then setting down these appropriate warm or cool areas, you gain a knowledge of painting. Your choice of hues is far less important than the accurate placement of warm and cool colors.

SOME SUGGESTED SKIN COLOR COMBINATIONS

Although I repeatedly state that the choice of color hues must remain with the individual artist, I offer some suggested color mixtures that may serve at first

as a guide for you, before you strike out on your own. However, copying these mixtures slavishly is not as helpful as testing them, then improving and improvising on them as your instinct takes over and your natural inclination guides your color selections.

Caucasian or White Skin. The basic mixture for white skin is red, yellow, and white in various combinations. Reducing this to terms of particular tube colors, white skin in warm light areas is a combination of Naples yellow and white. In cool light areas, white skin can be painted with Naples yellow, white, and a touch of cerulean blue. In transitional or halftone areas, terra rosa and white can be used, and in shadow areas, yellow ochre can be used.

Olive Skin. For the Latin-type brunette with olive skin, you could use the same colors as for white skin, with the addition of Naples yellow. For shadow areas, you may add yellow ochre. Remember that you are working on top of a grisaille and that its tones provide a base for these flesh colors.

Black or Brown Skin. This type of complexion is formed by a basic mixture of red, yellow, and white, plus a good dash of yellow ochre. In cool light areas, you can use cobalt violet and white or cerulean blue and white. When the light is warmer, you may substitute yellow ochre for the blue or violet. In transitional areas, terra rosa, Mars orange, and white, plus pure yellow ochre expresses the skin color. In shadow, you may use yellow ochre, Mars orange, and raw umber.

Oriental Skin. Again, the same mixture as for white skin can be used, with additional cadmium yellow pale or yellow ochre.

Indian Skin. Here, too, the mixture is the same as for white skin, with the addition of Naples yellow (with perhaps less white) and cerulean blue in areas in the light, and with yellow ochre plus chromium oxide green in transitional areas, and yellow ochre and raw umber in the shadows.

Skin Outdoors. Outside the studio, the skin picks up reflections from all the lights and objects outdoors. Accordingly, I usually see to it that mixtures of ochres and cerulean blue are spotted in for color accents to represent the generally green aspects of plant life or the effects of sunlight and the blue of the sky.

SOME SUGGESTED HAIR COLOR COMBINATIONS
The following hair color mixtures are possible:

Blond Hair. In light areas, blond hair can be expressed by Naples yellow, white, and a touch of cadmium scarlet. It can also be painted with cadmium yellow pale, white, and terra rosa. In transitional areas, you may use cobalt violet, and in shadow areas, yellow ochre.

Red Hair. For red hair, I work over the tones of the grisaille with cadmium scarlet.

Brunette Hair. For the hair that goes with Latin-type olive-skinned complexions, I use either raw umber or Mars orange.

Black Hair. For the type of hair that goes with black or brown skin, I use raw umber, cobalt blue, and alizarin crimson: raw umber alone in the light areas, and the other two colors for the shadows.

EYE COLORS

To paint eyes, you must think of them as an extension of the subject's skin. What I generally do is carry over the flesh color into the eyes so that no sudden break occurs between the skin and the area referred to as the "white" of the eye.

Toward the end of the picture, when I need to specify the color of the iris, I add a touch of cobalt blue with raw umber for blue eyes, raw umber or yellow ochre for brown eyes, and a blue and yellow for green eyes. I paint the pupil in raw umber and the highlights or catchlights in the eyes, if they are present, in a mixture of white and yellow—never in pure white alone.

KEY

Key is the overall tonality in a painting. "High key" means that the overall tonality is toward the light, bright side, while "low key" expresses a more somber, darker tonality.

I lean strongly toward a higher key and I urge my students to do the same since, to me, a high key painting represents a number of positive factors: it means more light, and light evokes an exciting, thrilling visual experience. High-key painting approximates the brilliance of actual light, though no paint manufacturer can ever really duplicate it. Thus, the higher the key a painter adopts, the closer he approaches reality. High-key painting is generally happy and joyous, while low-key painting tends toward the depressing and the melancholy. High-key painting is modern and contemporary. In older times, houses possessed few and narrow windows, so that low-key painting suited the mood of the day. Today, bright and cheery rooms are the ideal. Another reason the Old Masters painted in low key was unavailability of the bright, vivid colors so readily accessible today.

SOME GENERAL NOTES ON COLOR

Here are a few general pointers to remember about color.

There is no such thing as local color. Local color means the actual hue of an object, such as a *red* dress. But to an artist, there is no such thing as local color; only the effect of light striking an object. Thus, a red dress illuminated by a strong, cool bluish light will now assume the characteristics of that light and will no longer be red per se, but a combination of hues as affected by a specific light. The only place an object presents local color is in the *transitional* areas. Thus, a pink dress may be blue and white in the areas facing the light, brown in the shadows, and pink *only where it turns from the light toward the shadow.*

Mix your colors on the canvas, not on the palette. This is a difficult concept to explain, but try to think of your painting as a mosaic, and each brushstroke as a colored tile which, when seen in combination with the other tiles, forms a color symphony.

Always mix complementary colors. Red mixed with green is generally more exciting than red mixed with pink. Always try to balance one complementary color against another. This will add sparkle to your painting.

Paint in yellows and blues only. Yellow is warm and blue is cool. Try, in your mind, to separate *all* your colors into a very broad division of yellows and blues. Thus, all your warms should be thought of as yellows, all your cools as blues. Also, every yellow should have a violet or a blue somewhere to complement it, and vice versa.

Keep the color of the subject and the background related. The hue and temperature of the colors in the background should not exceed those in the subject. The same applies to its values.

Vary the temperature of your lights and shadows. Your lights can be either warm or cold, as can your shadows; but for greater color impact, whatever you make one, make the other different.

Decide on an overall color scheme. Always plan the overall color scheme of the picture beforehand—is it basically pink? orange? green? and so forth. Do not ignore this consideration or let it evolve on its own without your guidance and supervision.

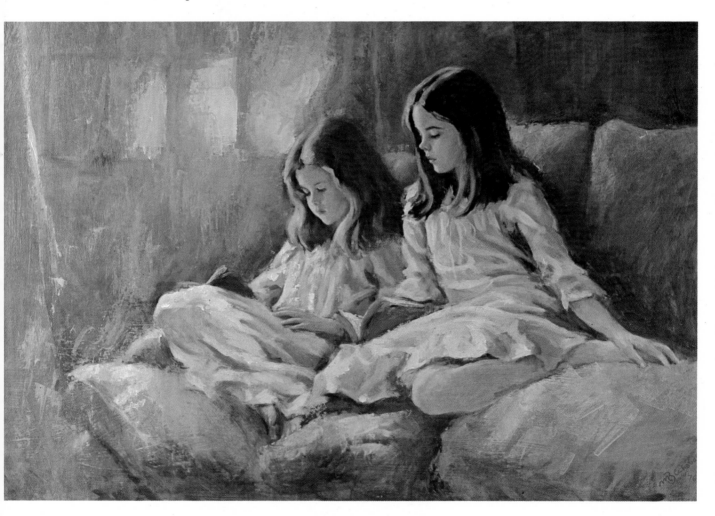

Valerie and Cecily, The St. John FitzGerald Sisters. *Oil on board, 20″ x 30″ (50.8 x 76.2 cm). Collection of Mr. and Mrs. Henry St. John FitzGerald. The cool violet gowns contrast with the orange-red accents in the sofa and background for the utmost charm and effectiveness of color. Every painting should include such a balance in whatever proportions you elect. Had the gowns been of some warm color, much of the painting's impact would have been lost, I think. The human eye instinctively looks for variety in color and it is your obligation as an artist to provide it.*

Girl with Apples. *Oil on masonite panel, 36" x 36" (91.5 x 91.5 cm). Collection of Dr. and Mrs. William J. Gazale. In this nearly all-warm painting, the cool accents are the bluish notes in the collar and in the sleeves of the sweater. I chose an all-rose-colored board for this painting for a surface with a tone similar to the overall color scheme I planned. Over this, I was able to lay the warm and cool accents I wanted. It is a good practice to keep a number of various-hued boards and canvases in readiness for any type of painting.*

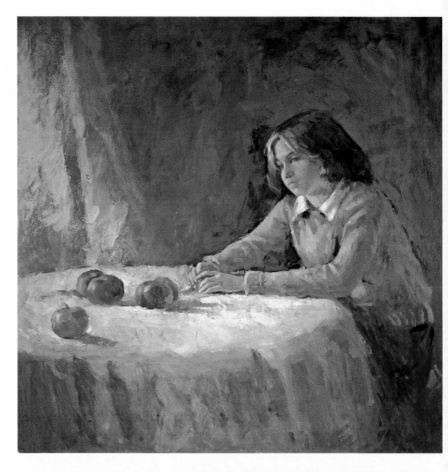

Homework. *Oil on masonite board, 20" x 20" (50.8 x 50.8 cm). Collection of Dr. and Mrs. William J. Gazale. Note the dispersion of color in the background. Darker and lighter patches of warm color are interspersed with cool accents here and there. I prefer my backgrounds indistinct, and merely an extension of the tones and colors found in the subject. Note that no color in the background is darker than the darkest area on the subject nor lighter than the lightest.*

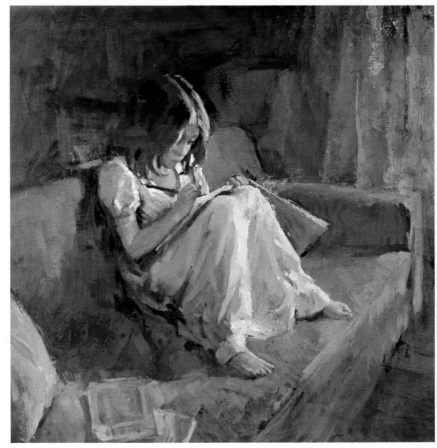

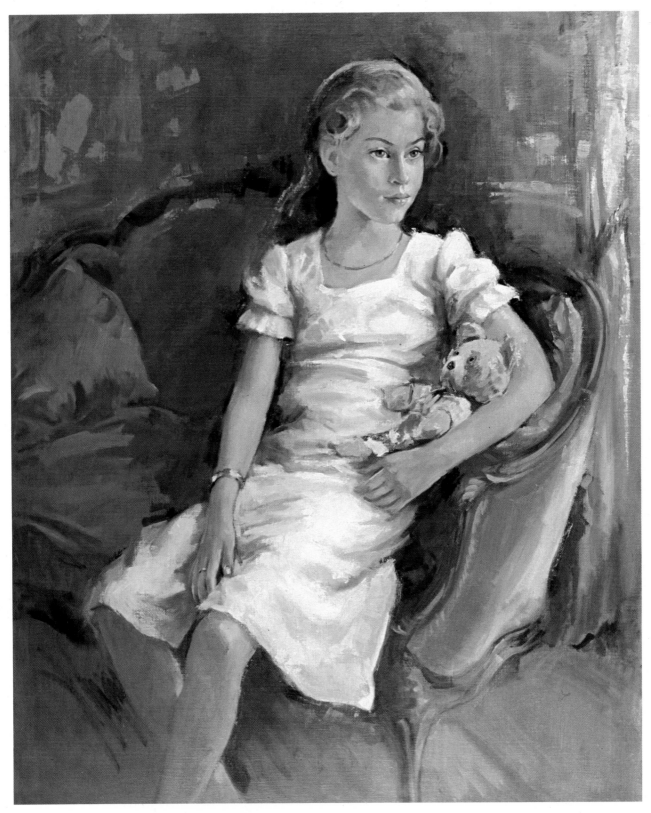

Stephanie L. Davis. *Oil on canvas, 32″ x 26″ (81.3 x 66 cm). Collection of Mr. and Mrs. Edwin W. Davis. White is my favorite choice in dress because I see any color I want in it, and I paint it accordingly. Note the blue, violet, and reddish accents in the shadow areas. White picks up reflections of every hue and allows you to exercise your artistic license to indicate a variety of hues in what the average person would see only as a pure white area.*

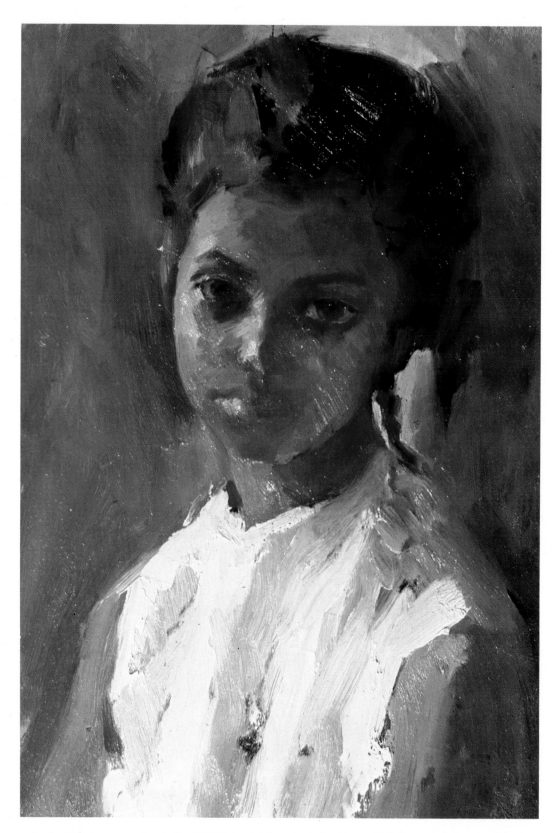

June. Oil on masonite, 19″ x 12″ (48.3 x 30.5 cm). Collection of Mr. James Seeman. Note how basically cool the reflected lights emerge on this dark-skinned subject. The light areas contain lots of yellow ochre and there are orange and reddish tones in the middle-value areas. A white dress is particularly complementary to a dark complexion. Note that despite the subject's dark coloration, I used nothing even resembling black anywhere on her face.

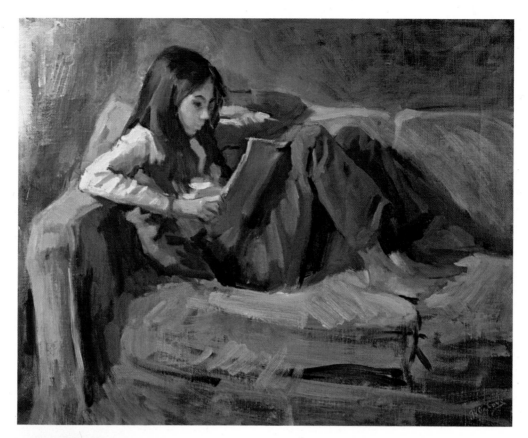

Pamela Reading *(Above). Oil on canvas, 16" x 20" (40.6 x 50.8 cm). Collection of Dr. and Mrs. William J. Gazale. Colors are capable of representing moods. Blue is usually associated with calm, languor, and serenity. In our culture, cool colors are generally associated with inaction and the warm colors with action. Try to conceive of this picture painted basically in shades of red. It might be just as effective, but it would project an entirely different mood.*

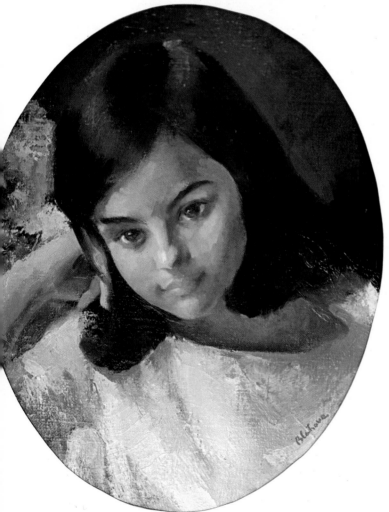

Dawn *(Left). Oil on canvas, approximately 15" x 13" (38 x 32 cm). Collection of the artist. This is an instance of warm colors encircled by cools. Outside of the model's lips, cheeks, left temple, and right arm, the rest of her figure, dress, and costume is made up of cools in the bluish, greenish, grayish range. Note how the white dress is handled—there is at least as much blue as there is white in it. As I mentioned earlier, white contains much of every color and accents on it should never be painted only white.*

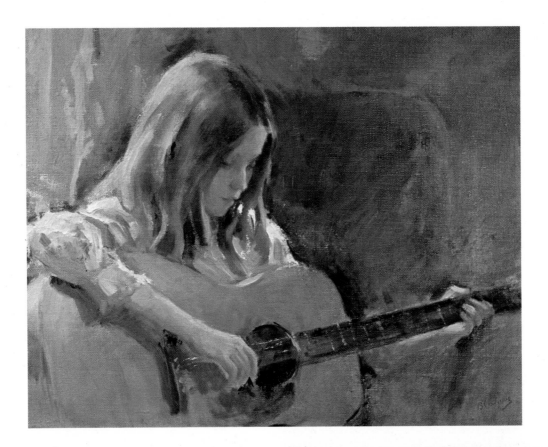

Young Guitarist *(Above). Oil on canvas, 11" x 14" (28 x 35.6 cm). Courtesy Georgetown Art Gallery, Washington, D.C. There is nothing lovelier than the effect of sunlight on light blond hair. To create this bright color, I usually mix several of my yellows, plus white as needed to lighten the color. I always prefer to use a combination of colors rather than one just as it comes from the tube. This lends sparkle and excitement to the mixture. However, I do my color mixing on the canvas, not on the palette. I compare this effect to a mosaic, with each brushstroke representing a different-colored tile.*

Tying the Shoestring *(Right). Oil on masonite board, 30" x 24" (76.2 x 61 cm). Collection of the artist. The T-shirt is white, but it has red, blue, and violet in its shadow areas; the jeans are blue, but its accents are red. From an artistic standpoint, there is no such thing as local color. Every object contains the colors that the light and surroundings cast upon it. All color in painting is subjective, a product of the painter's fantasy and imagination.*

Christina. *Oil on masonite, 14″ x 9″ (35.6 x 22.9 cm). Collection of the artist. Skin has a fragile, tender texture. Its color is translucent, reflecting the flesh and blood lying just beneath it. I therefore paint skin in an essentially light tone, reserving my darks for other areas of the painting. Note how softly the tones and colors are gradated within the body. High-key painting is the most realistic way to represent skin tones.*

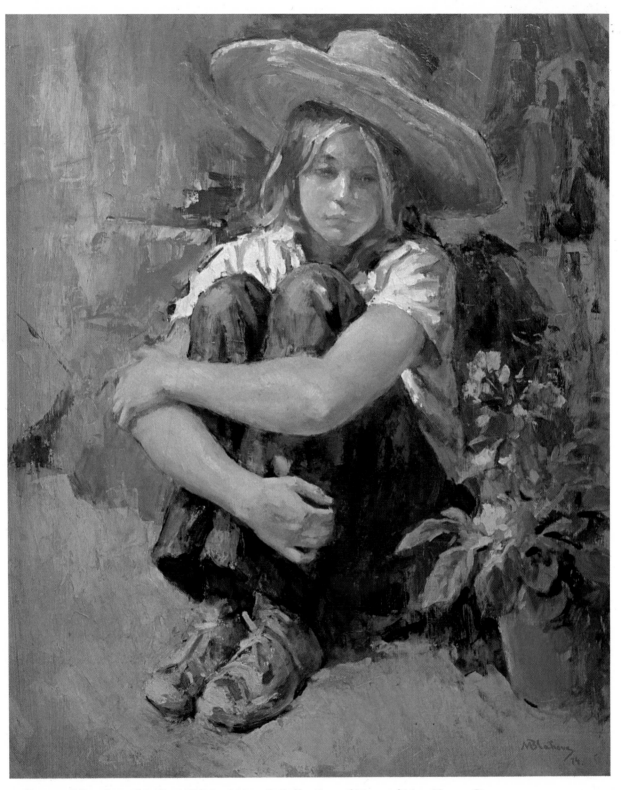

Penny. *Oil on board, 24″ x 20″ (61 x 50.8cm). Collection of Mr. and Mrs. Henry St. John FitzGerald. All flesh is a combination of red, yellow, and white. Fair skin in light areas is very high in value. It can be approximated with a mixture of Naples yellow, white, and a touch of cadmium scarlet, or with cadmium yellow pale, terra rosa, and as much white as is necessary. Cobalt violet is seen in the transitional areas and yellow ochre in the shadows. However, these are only suggested combinations—you should elaborate upon them and create your own mixtures. Every individual and situation is different.*

CHAPTER SEVEN

Painting Procedures

In this chapter, I explain my actual procedure in as much detail as possible as I proceed to paint a child, from first contact to the final stroke. This is a process I have refined through years of trial and experience. It may help to provide a kind of roadmap that you, too, can follow, at least at first. Eventually, of course, you will develop your own system, customized to your specific needs and urges, but this guideline may help you overcome some of the obstacles and stumbling blocks that all of us, even the most experienced, confront in the execution of a painting.

My usual painting procedure consists of six stages, four with the sitter and two without. These six stages do not necessarily involve six days, since some of the stages may take three to four days. The sittings with the model present last from two to three hours.

STEP 1. INITIAL SKETCH

This is the initial encounter with the sitter during which I strike up an acquaintance with the child and size him up as to proportions, coloring, bearing, attitude, and so forth. It is at this time that I formulate all my decisions regarding a general color scheme, the pose, the costume, any props, the composition, the lighting, and the size and format of the canvas. At the end of this stage, I know fairly accurately how the picture will look when finished and, barring unforseen circumstances, I proceed on this basis.

I formulate these decisions by sketching the child in four or five different poses in line drawings, as elaborated in a previous chapter. Then, having moved the child about the studio, having sketched him in various poses, and having decided whether I want him standing, sitting, lying, holding a dog, a doll, or whatever, I then select the pose from among the completed line sketches that is most striking, and proceed to the tone study. This, as I have already stated, is drawn as carefully and as accurately as possible, since it must provide me with all the information I will need to go further. I want it precise enough so that I could, ostensibly, complete the painting without the model present, if this proved necessary.

I then proceed to do a watercolor study, indicating all the color areas, or

failing that, I make pencil notations on the tone study itself instead of indicating the colors through actual washes. I then decide on an overall color scheme and determine if my light areas will tend to the orange or warm colors, or to the blue or cool colors. I am now ready to proceed to the next stage.

STEP 2. GRISAILLE
This is the most important of all the stages, for it is in this one that I establish in visible terms on canvas all the decisions I have formulated in the previous stage. This is also the stage where I work entirely from my pictorial notes and without the model.

The first thing I do is select the surface tone that will best suit the color and value requirements of the painting. I always keep a number of various toned boards and canvases in readiness, and I now choose the one that will provide the most appropriate color base. I then proceed with charcoal to make an accurate reproduction of the tone study on canvas.

The next step is to sketch in with brush and oil color over this charcoal study. The color I use is matched to the color of my overall scheme. If it is to be a basically blue picture, I will sketch in with blue, and so forth.

I then proceed to cover all the areas of the painting with grisaille—warm or cool as determined in the previous stage. I place lights and darks where appropriate, but always applying the color in light washes thinned down with turpentine.

I make sure to provide the whole painting with an accurate tonal relationship, since my system is based on the theory that if the values are right, all else is incidental. I do not worry about color in this stage but seek only to set down all the lights, darks, and transitional areas in proper proportion to each other.

I find that executing this stage without the model present helps me to be more loose, free, and unencumbered. I have all the facts before me in the sketch and I rely upon my intuition to produce something creative and meaningful in terms of paint on canvas.

STEP 3. FULL-COLOR PAINTING
In this stage, I call in the model again. By now the surface of the canvas is dry—all the layers were painted in thinly and, therefore, have dried quickly—and I go over the entire canvas with the poppyseed oil-water medium I described earlier. This provides me with a mildly oily surface for overpainting, and even though I will be working on only part of the picture, I like to have the entire canvas receptive to any additional accent I might wish to include.

In this stage, I use the full-color palette. I proceed to paint only the child's head—but to completion. I may begin with the shadows and work toward the light, or vice versa. If the canvas is tinted—which in effect already provides a medium tone—I put my darks in first and my lights last. If the canvas is untoned—which means the lights are already evident in the white of the canvas—I put in the medium tones first, then the darks. By now, I will have established if my lights and shadows are to be respectively warm or cool, and I proceed on this basis.

By the time this session is over, the head will be ninety-nine percent done, except for some final finishing accents that may go in at the end.

STEP 4. BACKGROUND ELEMENTS
This time, I again rebrush the entire canvas with my "retouch" medium, and proceed to paint in all the other elements outside of the head—the figure, cos-

tume, hands, props, and background. I do not touch the head at all, since I consider it complete. Any final accents or adjustments that may be required come later.

In this and in the previous stage, I may also dip my brush into the poppy-seed oil–water medium to gain even more fluidity in the brushstroke and to aid my brush manipulations. The old-time painters used to call this "painting into the soup."

STEP 5. PULLING IT TOGETHER

Again working with the model present, I now proceed to pull the whole picture together. I work on all the elements—head, figure, and background—at once, making all the necessary corrections, adjustments, and additions. By the time this session is concluded, the picture is, to all intents and purposes, finished and lacking only those last-minute touches that might occur to me before I put in my signature.

STEP 6. FINAL TOUCHES

I have put the picture aside to dry for three or four days. This gives me the chance to look at it again with a fresh eye and to see what final adjustments are necessary.

Without the model's presence, I study the painting carefully. Perhaps an area thrusts forward too aggressively and needs toning down. Or maybe another area seems too dull and lacking in color. I mix up a batch of my glazing medium and make the appropriate adjustments. A touch of a color over its complement will quickly bring down its stridency.

The painting is now finished, and I put in my signature.

PRIMING AND TONING THE SURFACE

The color of the surface plays a vital role in my method—I often leave parts of the toned area alone and let it show through. Therefore, it might be useful at this point to discuss how I prepare my painting surfaces, since I never paint on a canvas or board without first priming or toning it.

Linen. I use only single-primed linen, since I prefer to add the second priming myself. To prime it, I take flake white plus some of the desired toning color (if this is indicated), mix this with turpentine to a creamy consistency, and smear it all over the surface with a brush.

After ten minutes or so, when the turpentine has evaporated, I take the palette knife and work it into the wet surface to create a somewhat grainy and interesting surface. This manual procedure takes away from the dull, mechanical texture a manufactured canvas provides, and adds some interesting variety. Now I let the canvas dry for three days, after which it is ready to use. I vary the hues for the toning colors, but my tendency is toward the oranges and yellows since I usually prefer to paint in cool color over a warm undertone.

Boards. To prepare my boards, I first place six tablespoons of rabbitskin glue powder into one quart of warm water, mix it, and let it stand until it turns to a jelly-like consistency. Using a sponge, I then apply this solution to the board. To avoid any subsequent buckling, I apply the glue mixture to both sides of the board, and even to the edges.

When it dries, I sandpaper the side on which I paint (the smooth side of the board), then brush on a coat of flake white, thinned and mixed with color, just

as for the linen. Again I texture it with the knife. Or, I may let it dry, then add a second coat.

When the surface is dry, I sandpaper it gently to remove any bumps and impurities. The board is now ready for painting.

SOME NOTES ON GLAZING

Glazing adds unusual richness and depth to a painting. Accordingly, I glaze frequently, but never in the course of the painting; only at its conclusion.

I may glaze small areas of the painting or larger ones. Sometimes I glaze in an area, then wipe away much of it quickly before it dries to create interesting effects. I usually do not paint over areas I have glazed, but occasionally I may add an accent over it with a knife for a striking color note.

Because the glaze medium contains an oily base, the glazed areas may at first appear to dry glossier than the rest of the picture. Do not worry about this. After a period of months, the entire painting tends to become uniform and these slight differences are minimized. However, if you find that this does disturb you, you can brush on a very thin solution of Damar or retouch varnish over the duller areas to bring them up somewhat.

GENERAL NOTES ON PAINTING HUMAN SUBJECTS

I do not let myself become too concerned, as some students do, if the proportions of the painted head and figures do not match those of the subject down to the last fraction of an inch. An eighth of an inch here or there is not half as important as achieving expressiveness and character in the painting. Caricaturists exaggerate individual features to achieve likeness, and this is a trick you may well employ in your pictures of children.

If a child's face is round, do not hesitate to paint it even rounder than it actually is. You are an artist, not a mechanical draftsman. Seek to fulfill the esthetic requirements of the painting and do not be overly concerned if some feature is a trifle off in measure. It is fantasy and creative imagination that constitutes good art, not absolute fidelity. In time, you will learn to achieve good likeness. Perhaps it might be a good idea to wait three or four years until this facility is perfected before launching yourself as a professional portraitist. For the present, just try to produce good art—likeness will come with experience.

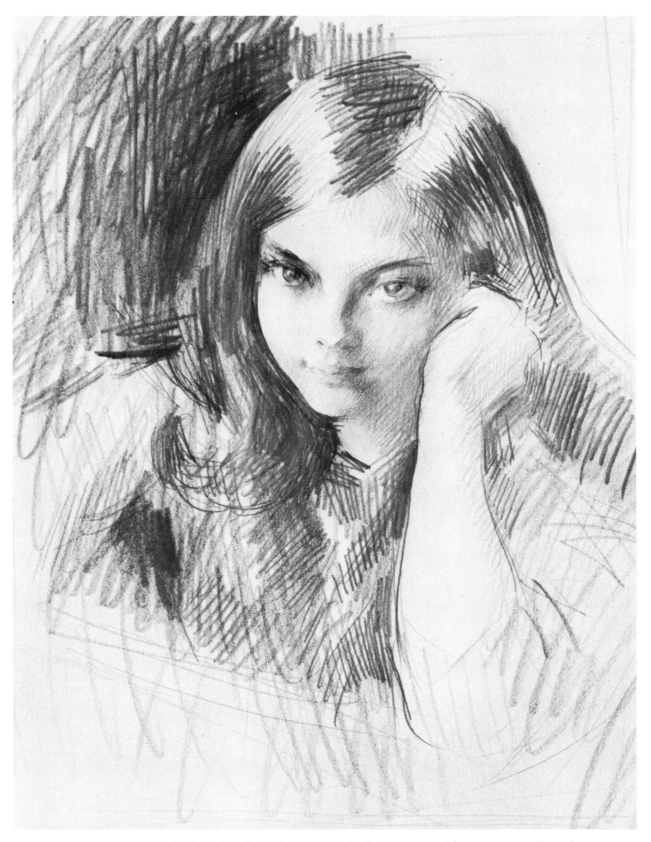

Step 1. Initial study. *This is the tone study that originated from a series of line draw-ings and that serves as the basis for the finished painting. All the factors of pose, light and dark patterns, and composition have been resolved. I have enough information here to finish the painting without the model, since I have also prepared a color study with notations regarding the various hues.*

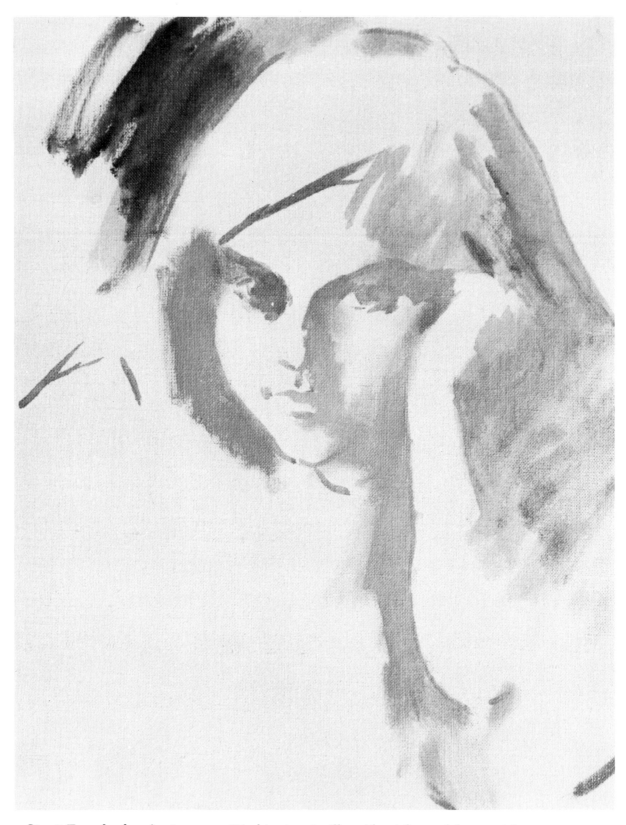

Step 2. Transfer drawing to canvas. *Working in grisaille, without the model present, I transfer the drawing to a canvas 11″ x 14″ (28 x 35.5cm). My oil tones are thin in this stage, as I am merely seeking to reproduce the main elements of the subject onto the painting surface. To achieve these washlike tones, I thin my paint with turpentine for a liquid, fluid quality, which allows me to fill in the areas without building up an impasto.*

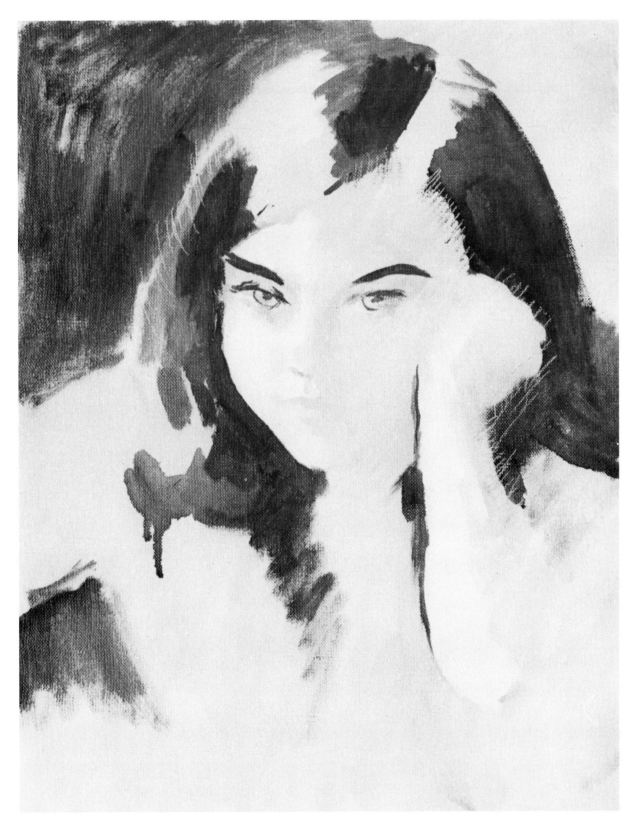

Step 2. The grisaille (Continued). *Still working without the model, I continue to elaborate the painting in tones of grisaille. I cover the entire area of the painting very thinly, with particular emphasis upon achieving a correct relationship among the patterns of the lights and darks. The following step will be to call in the model and to begin overpainting.*

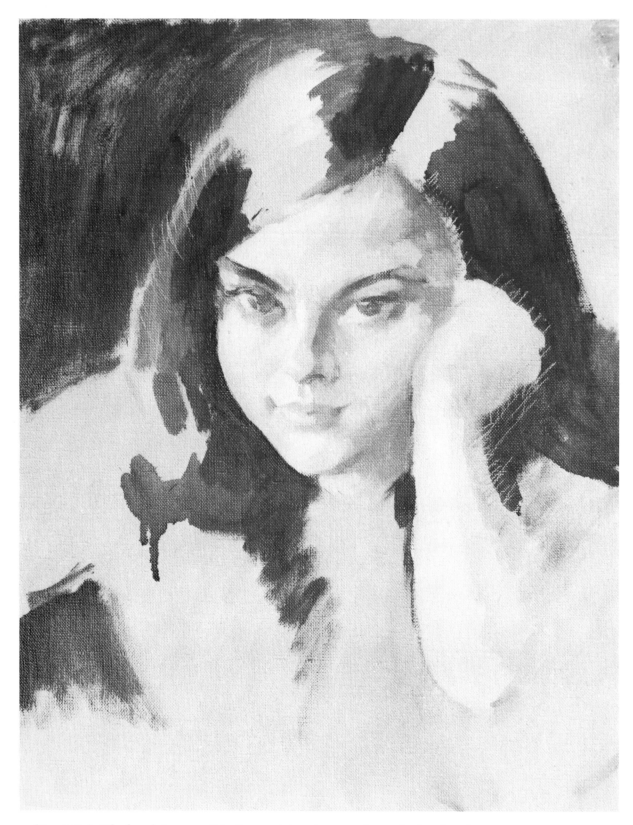

Step 3. Paint the head. *I now call in the model and proceed to paint her head as accurately as possible. By this time, I employ a full-color palette and I try to bring the face and hair to near completion. Of course, a number of finishing touches always remain for the final steps, including any glazing I might deem necessary.*

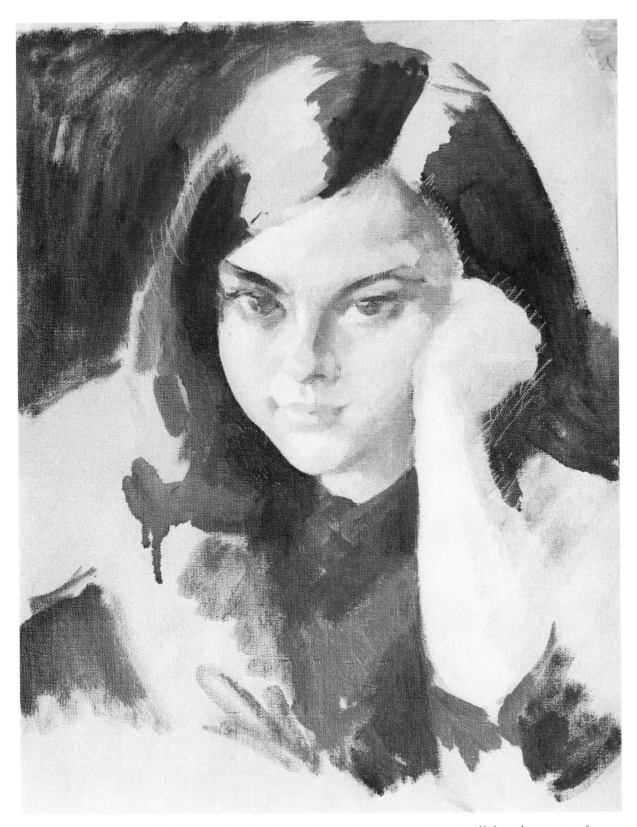

Step 4. Paint the rest of the picture. *I now turn my attention to all the other areas of the painting and—working as swiftly as possible—I try to complete them. This includes the figure, the hands, and the background. When this step is finished, the picture is completely covered with color in the appropriate value range.*

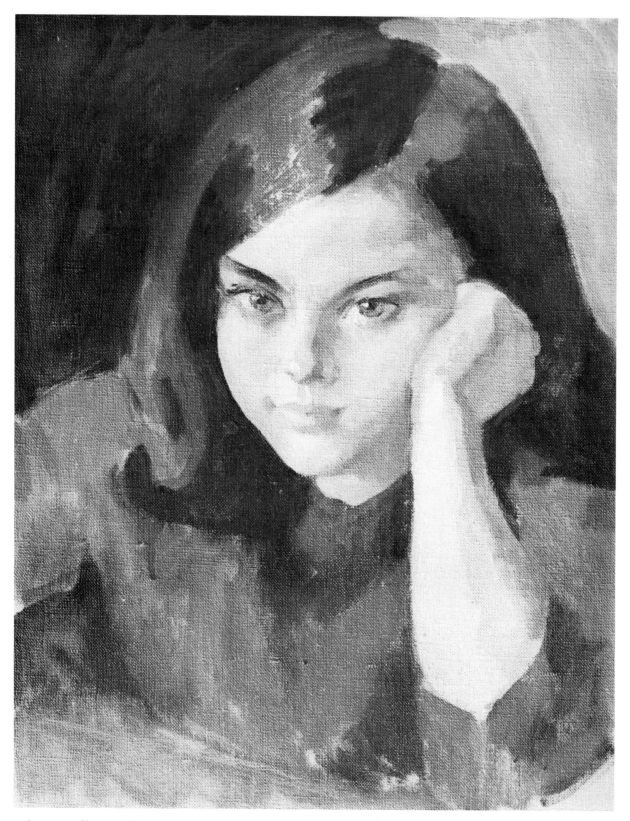

Step 5. Pull everything together. *I now pull the whole picture together, working all over it at once and making all the necessary adjustments, corrections, and alterations—if any are so indicated. The only thing remaining now is to see if there are any additional touches necessary. To obtain a fresh view, I now put the picture aside to dry for three days or so.*

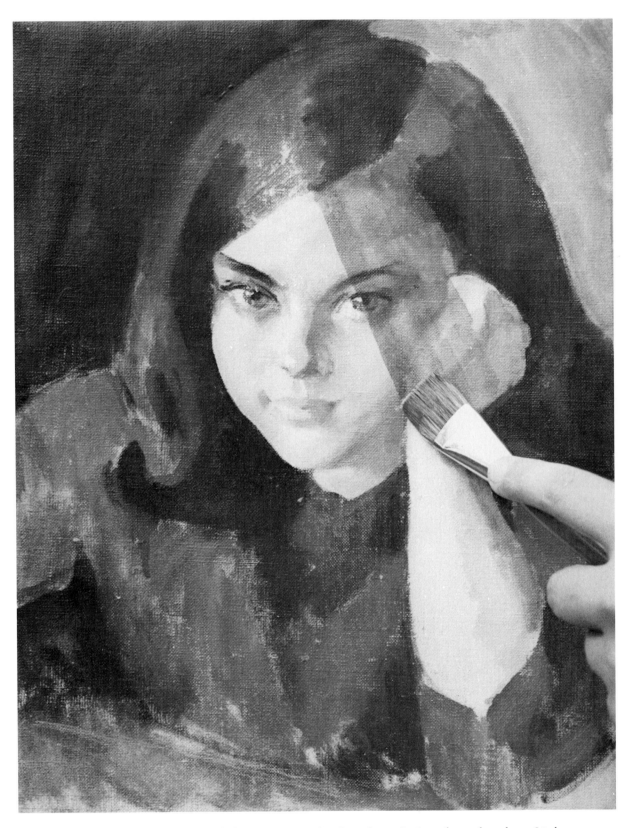

Step 6. Add the final glazes. *Coming back to the painting after a few days, I take a fresh look at it again to spot any finishing touches it may require. At this stage I determine if it needs glazing in certain areas that may be either too dull or too assertive in color. I decide to glaze. Having made my decision, I mix a batch of glazing medium and brush on the glaze in the appropriate area or areas with a broad sable brush.*

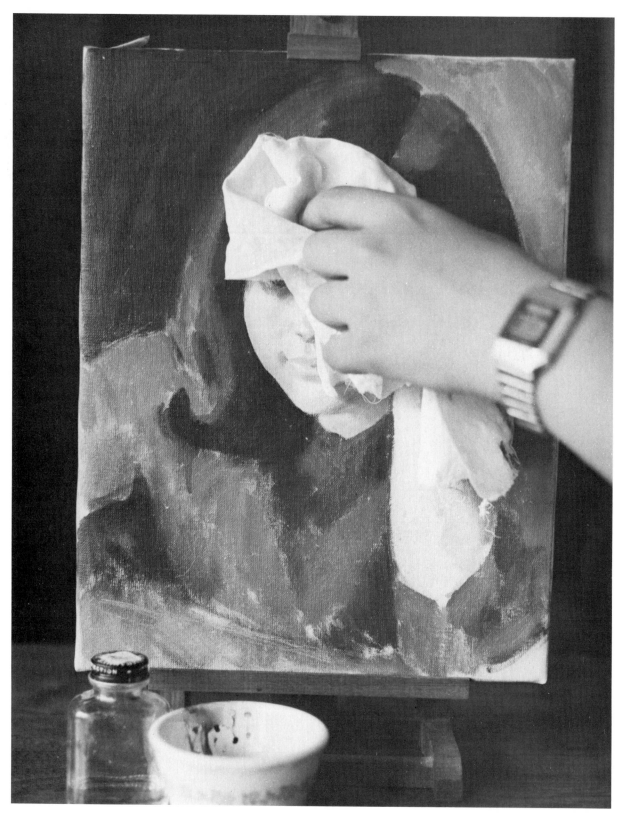

Step 6. Add the finishing touches (Continued). *Occasionally after glazing, I wipe out some of the glazed areas with a rag quickly, before it has a chance to set. This often produces interesting contrasts between glazed areas and those that are wiped out. Once in a while, I place a loaded stroke of paint with a knife over a glossy, glazed area for a striking, textural effect.*

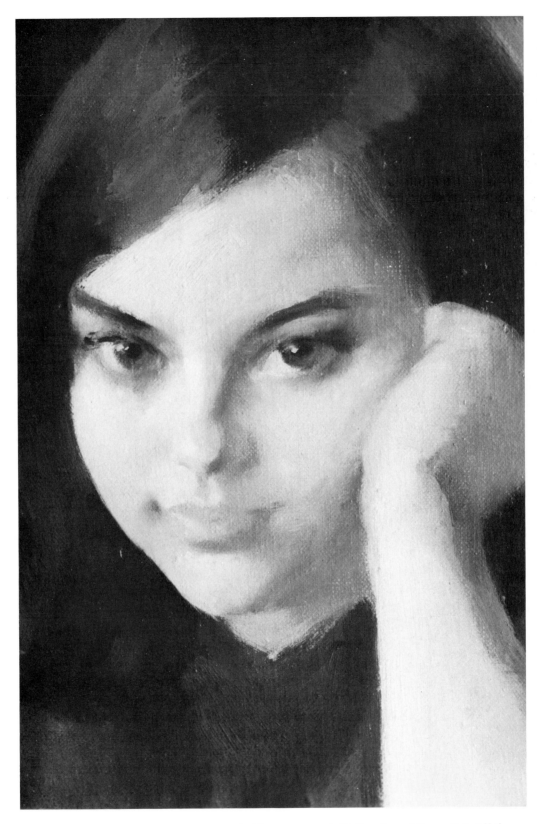

Dawn *(Detail). Oil on canvas, 11″ x 14″ (28 x 35.5 cm). Collection of the artist. All the necessary work is done. The fact that it looks soft all over is because of my urge not to paint too much. I paint just enough to make my statement, then stop. More pictures are ruined by overpainting than by underpainting. Set the goals firmly in your mind, then paint the picture as swiftly as possible. Once you say what you intend, lay the brush aside! (Finished painting is shown on page 44.)*

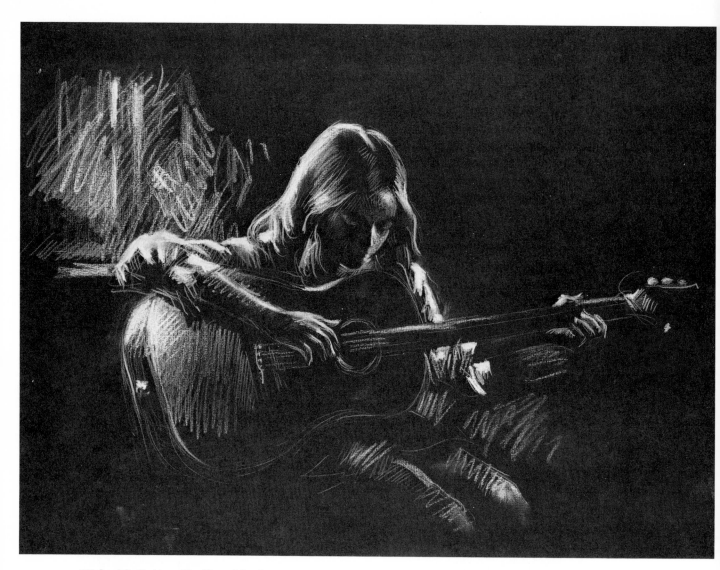

Girl with Guitar. *Chalk on black paper, 12″ x 16″ (30.5 x 40.6 cm). This is one of the means of drawing I suggest to my students to teach them how to see and think in terms of value. By drawing in reverse of normal, the beginning artist is forced to for- get such aspects of the subject as line, perspective, proportion, curves, and angles, and learn to concentrate on merely the factors of light and dark which constitute the basis of painting as I envision it.*

CHAPTER EIGHT

Learning About Values

My approach to painting is based almost entirely upon the aspect of value. I consider color and line as related, but much less significant, factors. Accordingly, I urge my students first to learn to see and identify values, and second, to use this knowledge in the actual process of painting.

Value is the term given all the tones (degrees of light and dark) apparent to the human eye. Under my system, the aspiring artist must first train himself to see everything around him in simple terms of light and dark. This means consciously avoiding seeing color and line, and looking at the world in grades of values only. This takes some doing since, from early childhood, we have been conditioned to think of persons and objects as tall, short, fat, round, blue, green, pink, yellow, brown, and so forth. What I propose is quite startling—forcing yourself to see these same persons and objects not as specific colors or shapes, but as areas of light and darks that only incidentally happen to be composed of various sizes, shapes, and hues, and the like.

Once having accepted this radical approach, we next go a step further and let our perceptions include halftone—that which is neither light nor shadow but lies in-between. This means seeing the world in terms of *three* values—light, halftone, and dark—and classifying every visual element into one of these three categories.

Of the three values, light is far and above the most important. This is because light is where the viewer's eye settles first, and because light is where most of the color is concentrated. So if I were to paint a person sitting by a window that was brilliant with light, I would center my attention on the window rather than on the human being, since its brightness would demand its prominence. It follows, therefore, that in teaching my students to see in terms of value, I suggest that they *look for the light areas first*, the halftone areas second, and the dark areas last. And finally, I urge them to look for the *patterns* and *shapes* formed by the three kinds of value, with the emphasis always fixed on the light values.

For artistic purposes, it is more important to look for the shapes of areas of lights, halftones, and darks than the shape of individual features. By looking

for the shapes of these value areas and by putting them down accurately, the dimensions of the various features emerge correctly. When painting, I often turn my canvas upside down to see if I have captured the shapes of my light areas. If they also seem to harmonize with the shapes of the other value areas and if they project a kind of rhythm. I know the painting will be successful.

Because of this basic three-value approach, I consider it harmful to have too many tonal variations in any one painting. But, while three values would be ideal, it is not quite enough. So I compromise by breaking up each of my values into two. Thus, I end up with two lights, two halftones, and two darks—a total of six values in all. Occasionally during the progress of painting I extend my values to nine, but I never lose sight of the basic six values. The best, the easiest, and the most powerful approach to painting is simplicity.

The following five projects are designed as useful exercises to acquaint you with a practical approach to my system of learning to see, identify, and put down values.

PROJECT 1. WORKING IN LIGHT ON DARK

This is a lesson in learning to see in terms of black and white only. In using this concept you reduce all the visible aspects of the world to two values only—lights and darks. You do not use transitionary or halftone areas, and the use of contour and line is avoided altogether. Since you begin with an all-dark surface, only the areas of light remain to manipulate. By picking out the light areas on black paper with chalk or white pencil, you achieve a representation of a recognizable human figure. This teaches you that what you see before you can be transformed into patterns of light and dark and that, by employing the aspect of illumination alone, a presentable work of art can be achieved. It takes some time to train your mind and eye to accept such a concept for, in traditional art education, you have been trained to concentrate on such other aspects of the painting process as getting the nose just so in relation to the ears, or measuring the distance between eyes and ears. My approach is to concentrate on getting the relationships of the values right. Once this is achieved, all the other aspects, including color, automatically emerge correctly.

This project and the four others that follow are calculated to help train you to use values as the primary basis of painting children—and everything else, for that matter. Once you have learned to see the world in terms of light and dark—and later, in terms of light, halftone, and dark—you will find painting much more natural and spontaneous.

Step 1. Pick out the main lights. *Arrange and light your subject. On a black piece of paper, using chalk or white pencil, pick out all the light areas on the subject, beginning with the top and working your way downward. Select only the lightest areas within the subject and ignore all the halftones and shadows. Include some of the lights in the background to provide some structure to the figure.*

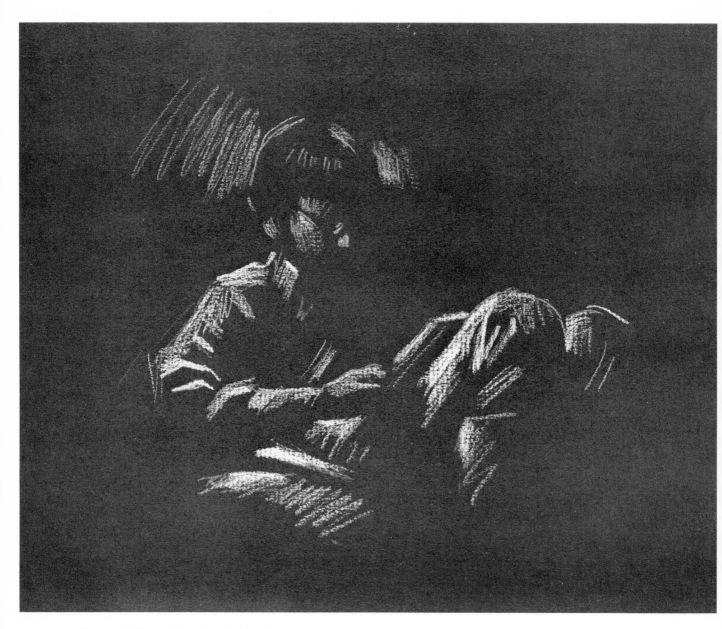

Step 2. Pick out the other lights. *Continue to seek out and put down the lights. Press down a bit harder in the very lightest areas that you would ordinarily paint as highlights in the painting. Avoid the temptation to outline any of the light areas, but merely lay in the strokes without concerning yourself about their outer or inner edges.*

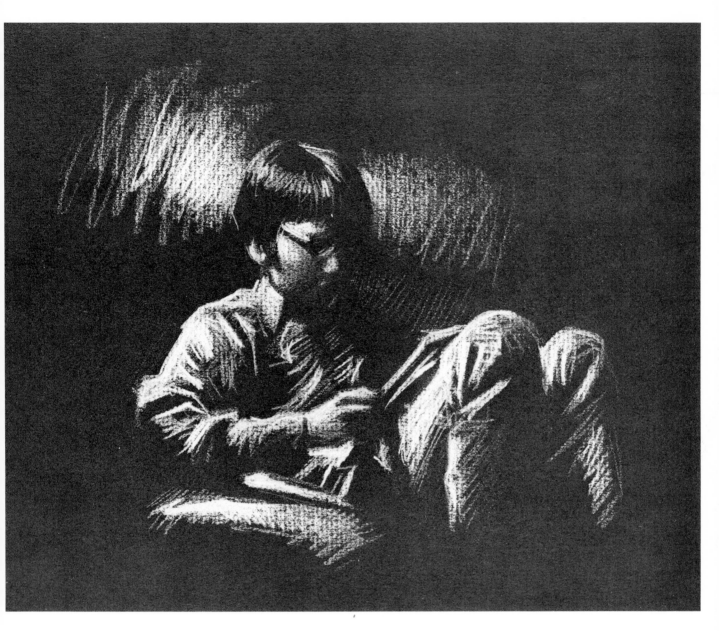

Step 3. Refine the image. *Put in every light you see—then stop. By the time you do this, a most realistic image will have emerged. Working in two values only, you can see that it is possible to even achieve likeness without resorting to other devices. Repeat this exercise again and again until you can execute it accurately and in less than ten minutes.*

PROJECT 2. WORKING IN DARK AND LIGHT ON HALFTONE

Having achieved results in light and dark only, you are now ready to advance to a third value—halftone. Halftone is that transitional area that separates light from dark. Halftones usually occupy perhaps two thirds of the painting surface and are therefore a vital component of the painting. Without them, the lights and darks would come together in a harsh, sharp edge and much of the beauty of the painting would be diminished.

In this project, let the tone of the paper serve as the medium or halftone value, so you draw in only the darks and lights. This closely follows my usual method of painting, because I normally begin with a toned canvas whose value is usually within the medium range and proceed essentially as you will in this project to lay in my lights and darks, letting the surface serve as the medium or halftone value.

Starting with a medium tone is an ancient and accepted method of working. It is only in recent times that artists have begun their paintings on a white canvas. Of couse, one could always consider the white canvas as *the light area* and go on to put in the halftones and darks (as in watercolor), but this is less productive than starting with a medium tone and working up toward the lights and down to the darks.

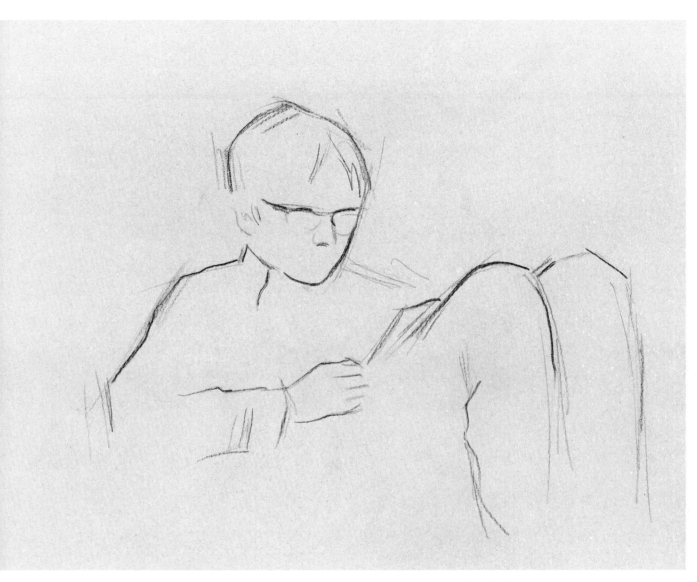

Step 1. Draw the contours. *Pose and light your subject. With a dark pencil on a gray piece of paper, draw in the general outline of the figure. Do no shading of tones at this stage; merely indicate the general outlines.*

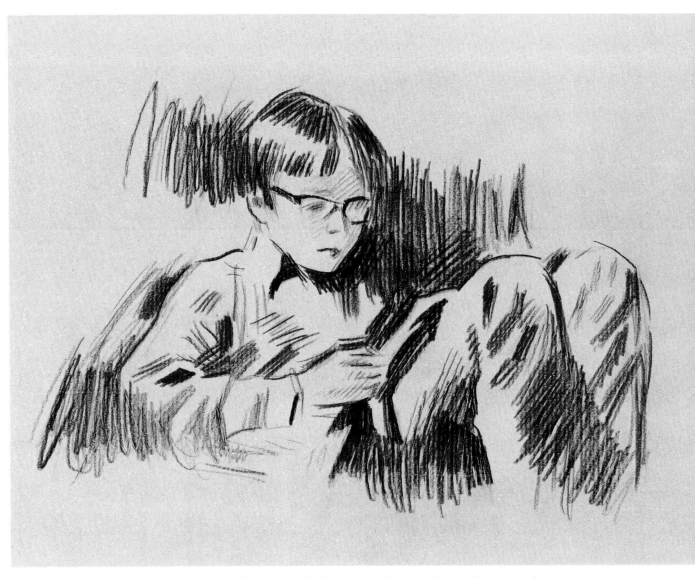

Step 2. Add the darks. *Proceed to put in all the darks wherever they fall on the subject. Do not concern yourself with the halftone or medium value areas—the paper takes care of those. Ignore the lights for now.*

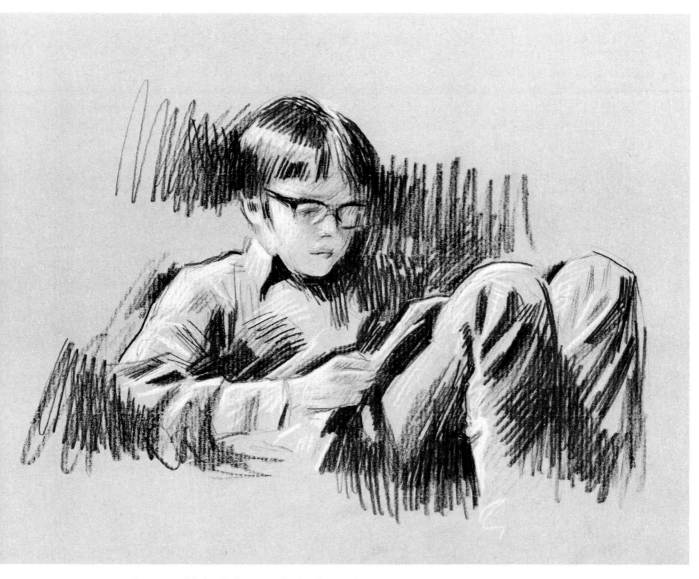

Step 3. Add the lights. *With chalk or white pencil, place all the lights. You now have a study in three values—light, dark, and halftone, which is the gray tone of the paper. Although three values will suffice for painting, I break them up further into six values—a lighter and darker light, a lighter and darker halftone, and a lighter and darker dark.*

PROJECT 3. WORKING IN DARK AND HALFTONE ON LIGHT

This project is comparable to painting on a white, untoned canvas. We normally sketch like this on white paper—without the use of any additional whitening agent, and most watercolors are painted this way, with the white of the paper representing the light areas.

This is the way you should execute your tone studies in preparation for the final painting. You can control the darkness of tone by the amount of pressure you apply to your pencil. Although you can control the light areas only by leaving them blank, this exercise should teach you to be conscious of the lights all the time you are drawing. Do not use an eraser. Instead, be aware of where the lights fall and take care not to draw into them. This is also comparable to drawing negative shapes. Negative shapes are those areas that surround or lie inside actual forms, such as the contours of the subject's body. By placing the negative shapes correctly, the positive shapes emerge accurately. If you lean your hand on your hip, the area formed between your torso and your arm becomes a negative area. When you draw its silhouette accurately, the shape of the arm and torso come out correct, too. What you leave out is just as important as what you put in.

Step 1. Draw in the big forms. *Pose and light your subject. With a dark pencil on a white paper, draw in the big forms of the figure. Mark off the shadow that forms behind the head. Do not look for accuracy of features, but seek to set down with fidelity the major patterns of the masses.*

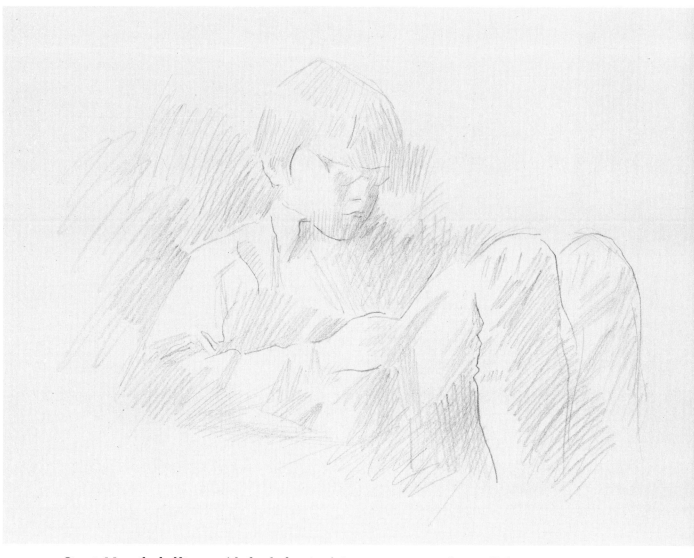

Step 2. Mass the halftones with the darks. *Applying easy pressure, lay in all the areas except the light ones, but do not make any distinction between halftone and darks at this stage. Merely cover whatever does not fall into the light category.*

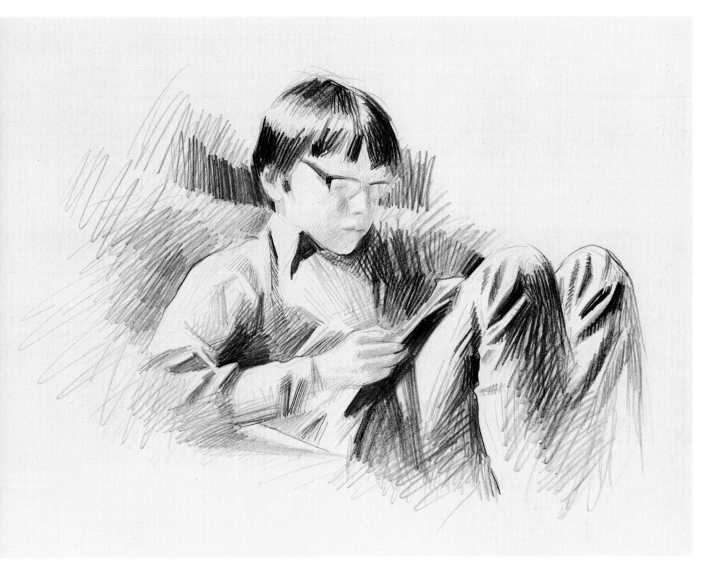

Step 3. Separate the halftones from the darks. *Now begin to distinguish between the medium and dark tones. Let the paper serve as the light areas. When you have completed, you will have a three-value drawing from which you could proceed to make a full-color painting.*

PROJECT 4. WIPING OUT LIGHTS ON A DARK SURFACE

Instead of *adding* values, in this project we work in reverse and achieve an effect by *removing* values. This might be compared to the art of cutting out silhouettes, where a scissors instead of an eraser is employed to remove unwanted areas.

This is merely another means of discovering value through the formation of shapes and patterns of lights and darks. In this exercise, we begin with an all-dark surface and, through the process of elimination, we achieve a semblance of reality. It is much like sculpting in stone. The sculptor begins with a block and proceeds to chip away all extraneous matter until only the desired form remains.

This exercise—and all the others in this chapter—are merely varied paths leading to the same conclusion—that all painting is based on the principle of light and dark, and that once a person learns to apply this principle, he will be able to paint any subject, from an apple to a head, with accuracy and fidelity.

Step 1. Wipe out the lights. *Arrange and light your subject. Cover a sheet of charcoal paper completely with soft charcoal. Now study the subject and use a kneaded eraser to wipe out all areas of light on the subject. Go for the biggest areas first and leave the detail for later.*

Step 2. Refine the smaller forms. *Proceed in the same vein, directing your attention to the smaller, less prominent lights in the head, figure, and costume. You can shape the kneaded eraser so that a fairly sharp point is formed. As you go on, try to be more and more precise in your erasures.*

Step 3. Add the finishing touches. *By simply going down to the tone of the paper, a fairly accurate likeness of the subject has been achieved. If you like, you can add a few darker accents with charcoal to provide some structure to the drawing, but this is a purely arbitrary step—the lesson lies in gaining a recognizable form merely by picking out the lights within the form.*

PROJECT 5. WIPING OUT LIGHTS, AND ADDING DARKS TO A MEDIUM-TONED SURFACE

This time we begin with a medium-toned surface. We then wipe out the lights and add the darks. Since we are working with oils, we must do the wiping out while the paint is wet enough to allow this procedure—which means rather swiftly.

Actually, all the exercises in this chapter should be executed as rapidly as possible. This is to teach you to read and recognize values in a hurry, and to learn to paint boldly and quickly. Once you have mastered the knack of seeing the world around you in terms of lights and darks only, you will have saved yourself hours of tedious labor on the painting itself. It is only during the period of planning that time is expendable. Once you have thoroughly planned out and visualized your picture, it should be painted with all the fervor and passion of inspiration—in one shot, so to speak.

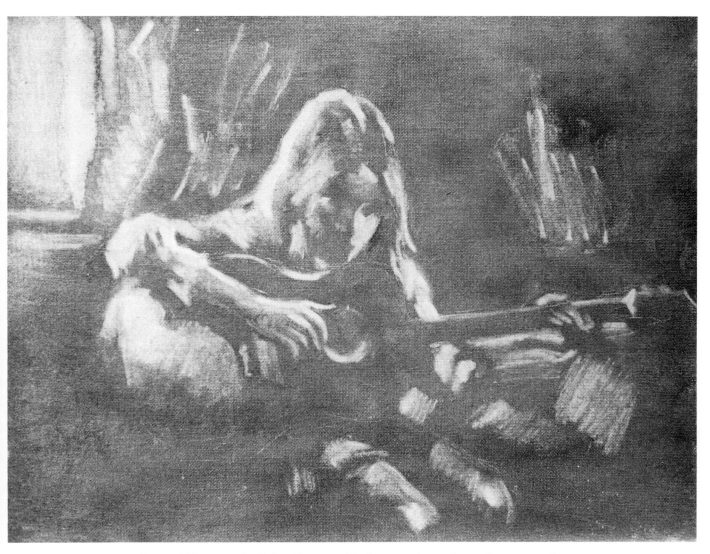

Step 1. Wipe out the lights. *Pose and light your sitter. Cover the entire white canvas with paint thinly applied and in a medium tone. Then with a rag saturated with turpentine, wipe out all the light areas on the subject and in the foreground and background.*

Step 2. Add the darks. *Mix a batch of darker color and put in all the darks. Remember, the canvas represents the medium tones, so add the shadow areas only.*

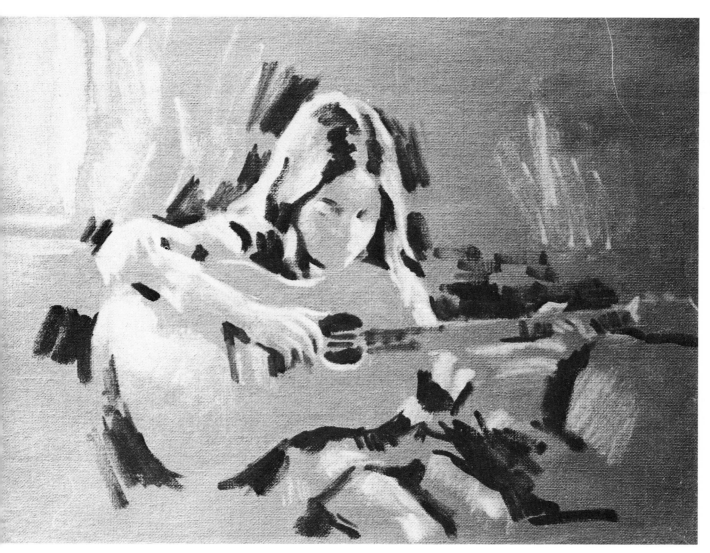

Step 3. Adjust the values. *Reinforce the lights and darks so that a distinctly three-toned painting is achieved. The picture should now be tonally correct in every aspect, so that it could be completed simply by applying the appropriate color over the respective value areas.*

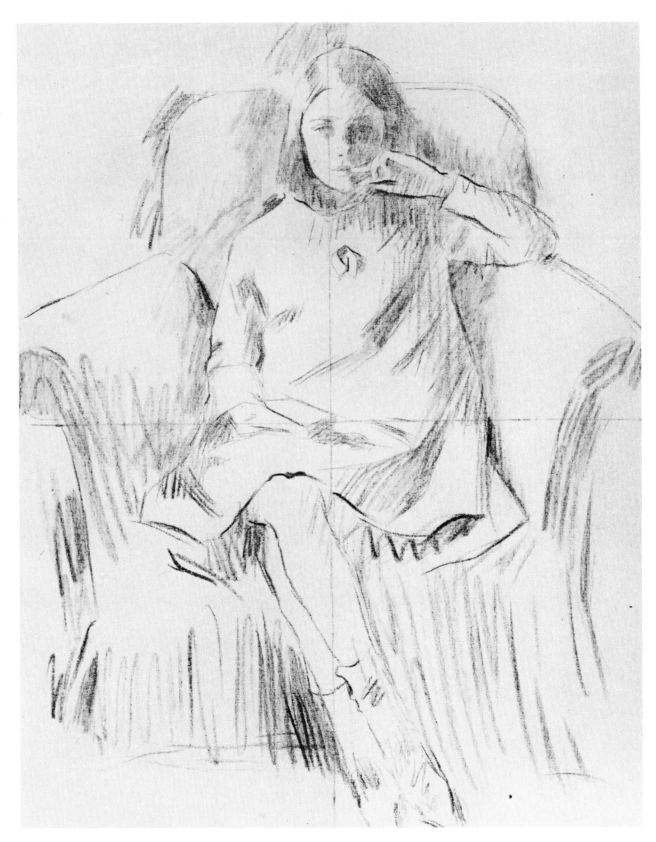

This is the way I draw with charcoal on canvas to prepare for painting Demonstration Five, **Girl in Blue Chair**. As you can see, I used the grid device to transfer the information from the tone study to the painting. With this sketch as a base, I now consult the somewhat more elaborate tone study and lay in the painting in grisaille as shown on page 134.

Demonstrations

The following five color demonstrations represent in visual terms everything I have been trying to teach you regarding my approach to painting children. They reveal in detail how I confront and solve five different problems that might arise in painting children, using the methods and principles described earlier.

By closely following the development of a painting as it progresses from stage to stage, it is hoped you may gain insight into the reasons that I proceeded as I did, and that you may absorb this knowledge and put it to practical use in your future work. Although the problems you encounter may not be exactly the same as those I am facing here, the principles I follow and the methods I employ to put them into effect may be gainfully applied to all situations in painting children.

If you first carefully read the eight preceding chapters and the one immediately following this section, "Handling the Brush and Knife," you will find these step-by-step demonstrations more meaningful, since you will be examining them with an eye toward the principles and procedures I have elaborated throughout the book. So read the book from cover to cover, then, with its content fresh in mind, follow me closely as I go through the developmental steps that lead from start to finish in each painting.

This is the nearest equivalent to actually looking over my shoulder and watching me work. I know that by returning to these demonstrations time and again, you will gather valuable information to help you in your own efforts.

DEMONSTRATION 1. GRISAILLE

This first demonstration is an exercise in value recognition, minus the use of color. It is painted entirely in grisaille, which means painting in shades of gray or neutral color. Since I keep reiterating that the student cannot progress to full-color painting until he has mastered the technique of painting in value, I urge you to paint picture after picture in grisaille until you have learned to establish value relationships and to balance the cools and warms which exist in grisaille as well as in full color. (There are, for instance, warm grays and cool grays, warm yellows and cool yellows, and so forth.) Actually, painting a picture in one hue of *any* color would technically be considered grisaille—it is not imperative that the color be gray. However, it is best that the color be of some neutral or subdued shade rather than of some bright, vivid color.

Once you have mastered the grisaille painting, you are ready to proceed to the next exercise, which is to paint in grisaille plus one warm color.

Step 1. Paint the outlines on canvas. *This demonstration is done all in one sitting, working directly from the model, without any previous studies. I use no pencil or charcoal, but start work immediately with brush and paint. Only the most basic data is indicated. I usually rely on a tone study for details of pose, tonal relationships, and composition. In this case, working from a model is similar to working from a tone study except for the color aspects that are not pertinent here since I am painting in grisaille only.*

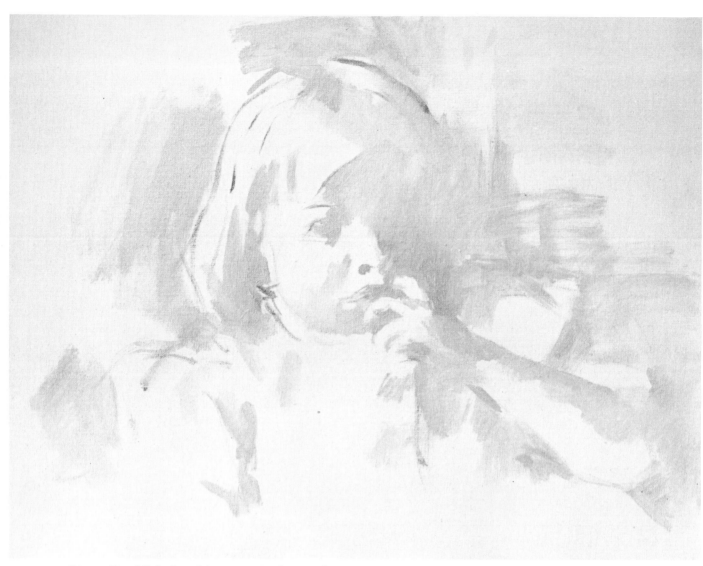

Step 2. Establish the white areas. *Reducing the consistency of my paint with turpentine, I cover all the areas of the painting except for the light ones in thin washes of a medium tone. This helps confirm some of the tonal relationships of the picture and sets the foundation for further exploration of the darks, lights, and halftones in their appropriate locations. Getting the white areas accurately established is essential, since I consider them the most important element in painting.*

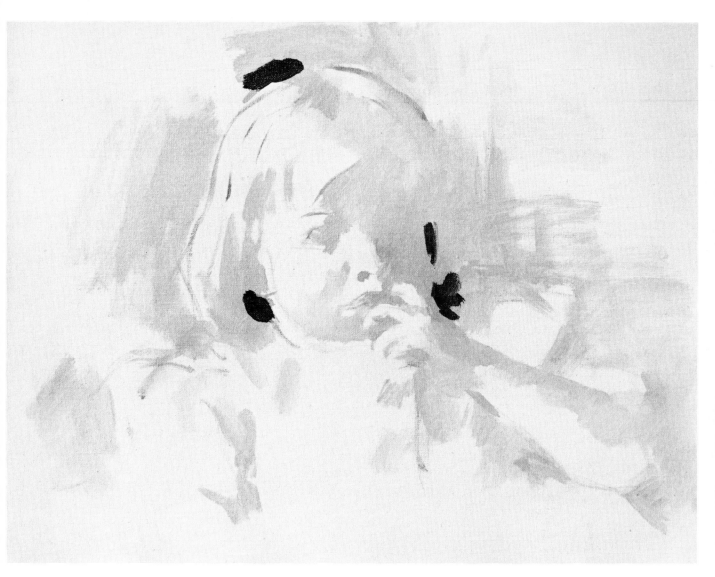

Step 3. Add the darks. *Now I mix up a batch of darker color and begin to place the darkest darks that abut the lightest lights, thus creating the sharpest edges.*

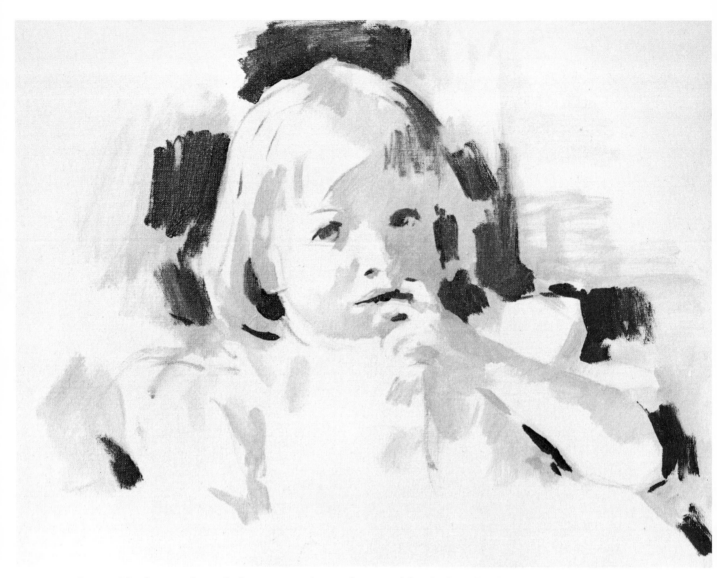

Step 4. Aim for a variety of edges. *Next, I lay in the rest of the darks. The sharpest edges (formed by the greatest contrast of values) are marked with a fairly distinct line; the softer edges (where such contrast is lesser in degree) are scraped with the palette knife to indicate that blending will occur there.*

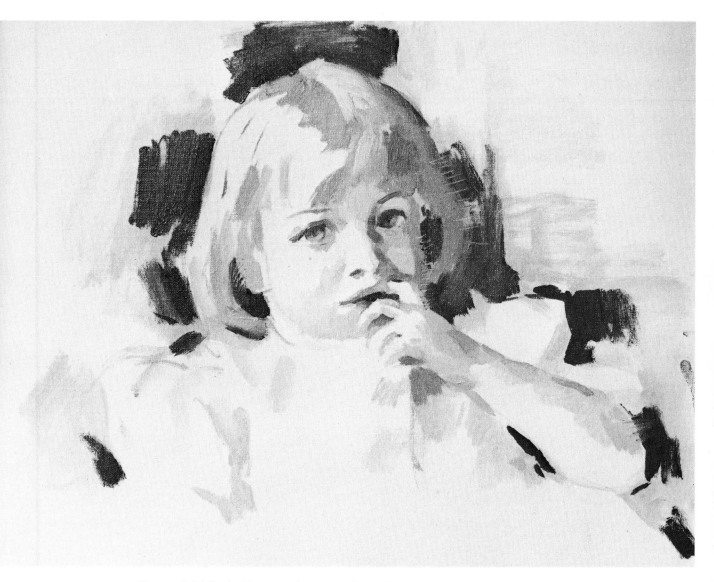

Step 5. Add the halftones. *I begin to place the medium tones in the head. The bare areas of canvas that were designed to represent the light areas are filled in with layers of paint. The entire head is now covered with light, dark, and medium tones.*

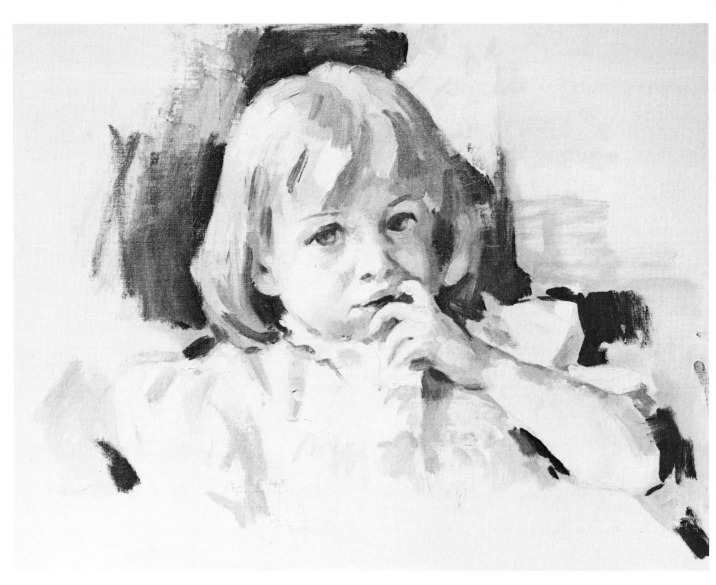

Step 6. Work on the background. *The head is fairly well finished and I turn to the other aspects of the painting—the dress, arms, and background. My brush is loaded with paint now and the strokes are laid freely—thicker in the light areas, thinner in the shadows.*

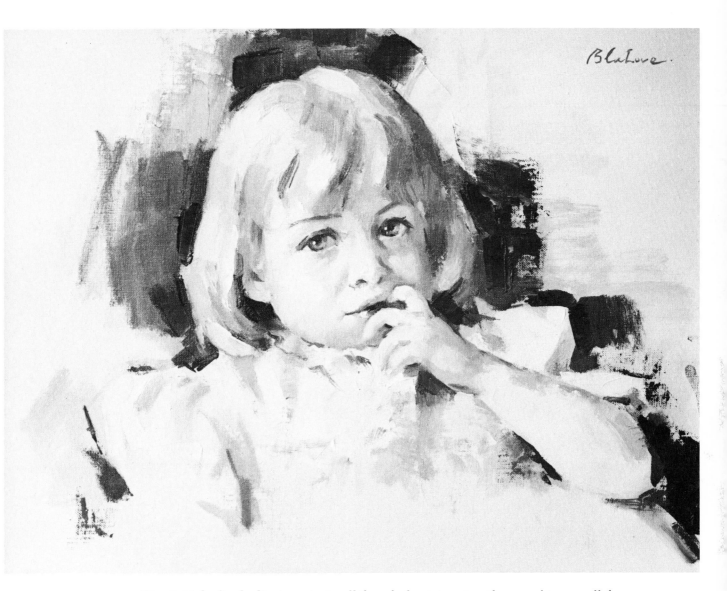

Step 7. Make final adjustments. *I pull the whole picture together, working on all the elements at once. All adjustments and corrections are made. The eyes are finished in detail and the catchlights are added. Edges are sharpened and softened as called for. Highlights are placed where appropriate with the knife. I now put the painting aside and let it dry.*

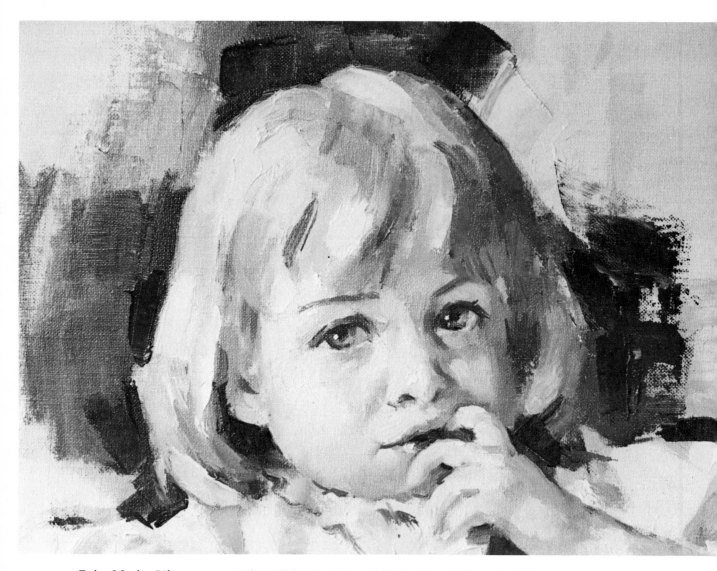

Paige Marie. *Oil on canvas, 12″ x 16″ (30.5 x 40.6 cm). Collection of the artist. The model has been dismissed. After three days interval, the paint is dry. I go over its surface with my stand oil-damar varnish-turpentine mixture and look for any additional areas that may need correction. Values and color are adjusted by adding slight touches of very thin washes that are equivalent to a glaze.*

DEMONSTRATION 2. COOL GRISAILLE PLUS ONE WARM COLOR

In this demonstration, I paint a mostly cool grisaille in bluish grays, then introduce a warm color (in this case, a cadmium orange) to show how much can be accomplished with a limited use of color. The completed painting could, in my opinion, pass for a full-color picture, not one in which a limited palette was used. Thus, once you have executed a number of paintings in pure grisaille, I urge you to add merely a single warm color to your palette rather than to go immediately to full color. The temptation to go to a multicolor palette is very powerful, but too often artists start painting with dozens of bright hues, only to grow frustrated and confused. Color is *not* the answer to successful painting. Color is comparable to running, and the artist must first learn to stand and to walk before he attempts the marathon. Learning values through grisaille painting is the basic training that must precede the total painting experience. (See pages 121–125 for demonstration steps.)

DEMONSTRATION 3. BLOND HAIR, FAIR SKIN

By the time you advance to full-color painting, you can begin to appreciate the immense variety of coloration in the human race. It is at this stage in your artistic development that you must sharpen your eye to the subtleties apparent in the different complexions and hair color.

First, look for the general coloration in your subject. Is he generally light or dark, cool or warm in color? Then see what happens when he is placed under certain illumination. Is he better shown in an overall cool or an overall warm color scheme? Finally, you must decide what kind of costume displays his individual coloration to best advantage.

In the course of your career, you will be painting all kinds of models. In the next two demonstrations, I paint two different physical types of children and show how I confront the problems presented by each of these types. (See pages 126–129 for demonstration steps.)

DEMONSTRATION 4. DARK-SKINNED MODEL

Dark skin is even more challenging to paint than so-called "white" skin in that it offers even a greater wealth of variety, running from deep almost purplish cool skin, through warm chocolate skin, to pale, olive shades. The mistake most often made upon confronting a dark-skinned subject is to immediately turn to blacks and browns without considering the facts.

Actually, there are blues, greens, yellows, reds, pinks, and violets in all skins, from palest pale to darkest dark. The only sane approach is to ignore what the mind has been taught and to rely on the eye. Trust your vision. Look deeply at the dark subject and force yourself to see the colors there. Is he really black? Is he truly brown? Rather than paint him in a single color that *seemingly* matches his complexion, probe deeply for the other, less obvious, color combinations evident in his skin. (See pages 130–133 for demonstration steps.)

DEMONSTRATION 5. BALANCING WARM AND COOL COLOR

This exercise is a lesson in the interplay of warm against cool color. I consciously chose an all-blue overall color scheme and posed to myself the challenge of how to place warm colors in limited but deliberate fashion to achieve a striking balance between warm and cool color.

The warms, as represented by the skin, book, bow, and shoes, constitute perhaps a tenth of the entire picture. Yet they are strategically placed in such a way as to produce the greatest impact. Note that they all fall in the middle of the picture—this immediately serves to draw the eye to them.

A balance of cool and warm color must be present in every one of your pictures. The actual proportion of cool to warm color or vice versa is your perrogative. It can run from 50–50 to 90–10, but its total absence dooms your painting to oblivion. All nature is balance. Just as you interplay your lights and darks, your angles and curves, and your rough and smooth brushstrokes, so you must play cools against warms—or risk having a dull, visually impotent painting. (See pages 134–136 for demonstration steps.)

DEMONSTRATION 2. COOL GRISAILLE PLUS ONE WARM COLOR

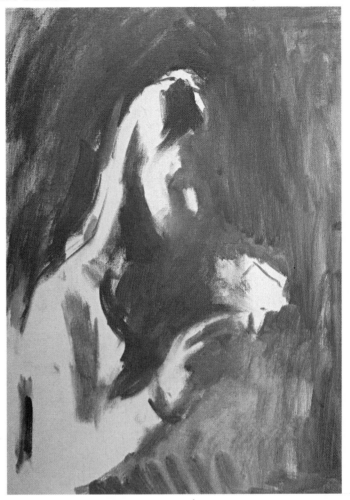

Step 1. Draw in the outline. *On an untoned board, I outline the light areas with a light gray mixture composed of raw umber, Prussian blue, and white. I mix three batches of color for the beginning of this demonstration—the first, a light gray just a touch darker than the white of the board; the second, a gray mixed of the same colors, but somewhat darker in value; and white. I use the first batch for this step.*

Step 2. Add the middle tones. *I proceed to fill in all but the lightest areas on the board with the light gray mixture.*

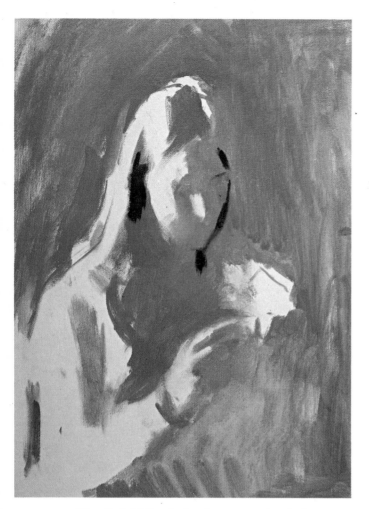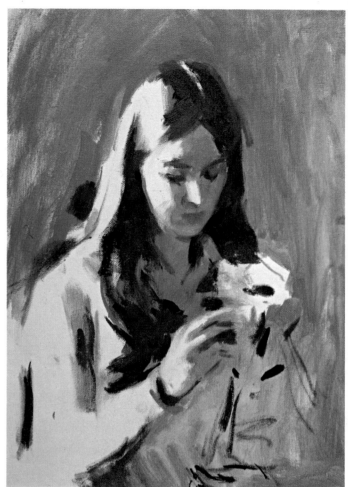

Step 3. Add the darks. *I now use the darker gray as I begin to indicate the darker areas of the board. The lightest areas are still bare at this point.*

Step 4. Continue to add the darks. *I finish blocking in the darks on the board with the darker gray mixture.*

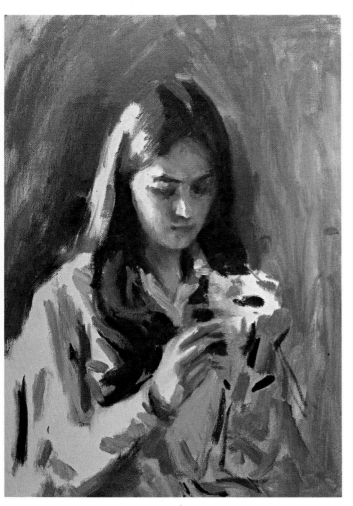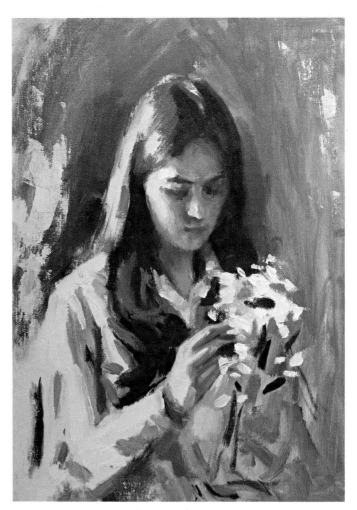

Step 5. Refine the middle values. *I now turn my attention to the medium tones of the painting. I divide these areas into lighter and darker half-tones and proceed to paint them in accordingly, using the lighter and darker grays, respectively.*

Step 6. Add the lights. *Taking up the palette knife, I now proceed to place whites alone or mixed with gray over the sections of bare board designated to represent the light areas within the subject.*

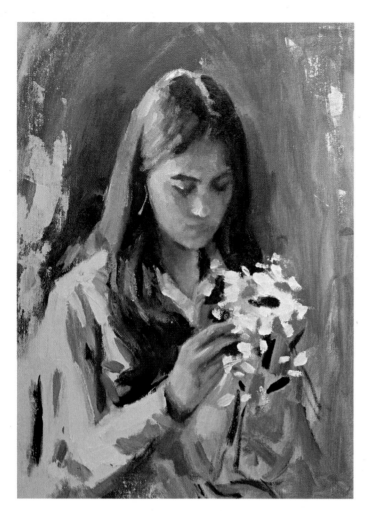 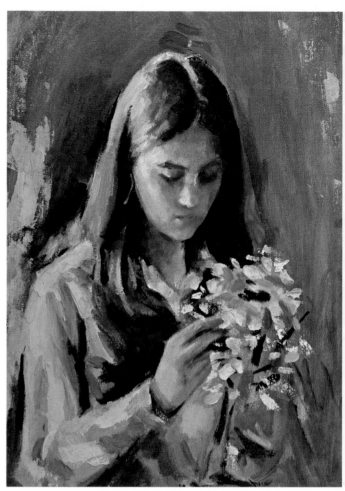

Step 7. Add one warm hue. *I add cadmium orange to the palette as the only warm color. The whole painting is scraped together with a palette knife to create a wet, receptive surface and then I place the orange in appropriate spots in the skin and hair with the brush and the knife.*

Step 8. Establish the background and add the accents. *I establish the shirt and the flowers with more care. Edges and darks are painted in with greater fidelity. I place dark accents in the background to better outline the head and figure.*

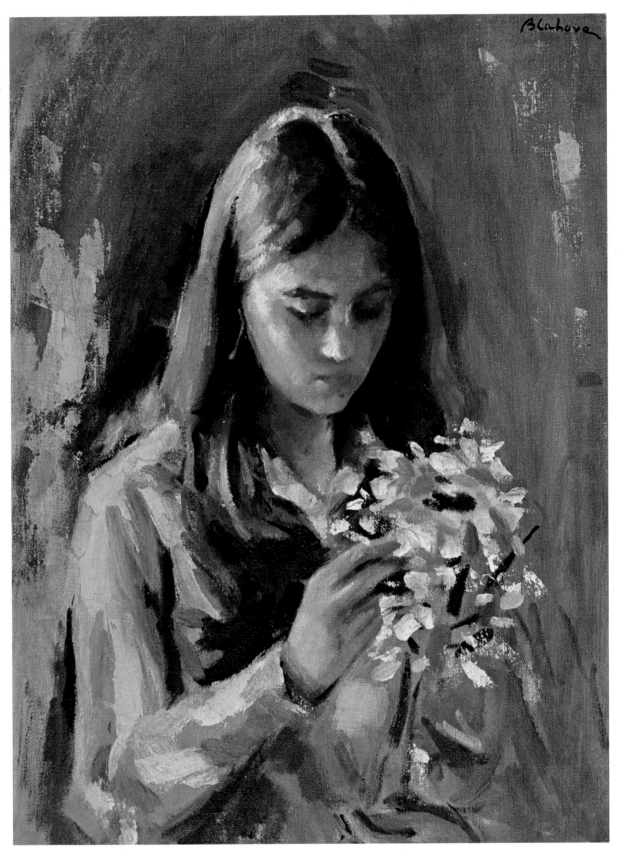

Girl with Flowers. *Oil on board, 16" x 12" (40.6 x 30.5cm). Collection of the artist. I use pure raw umber to accentuate the darkest areas of the painting. All superfluous detail is eliminated in the light areas, which are strengthened but simplified. I blend tones in those areas where the values run close together. A few highlights are spotted in as a final touch.*

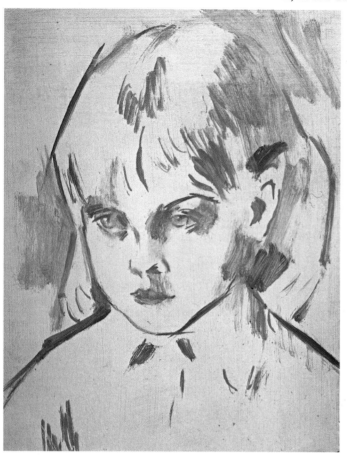 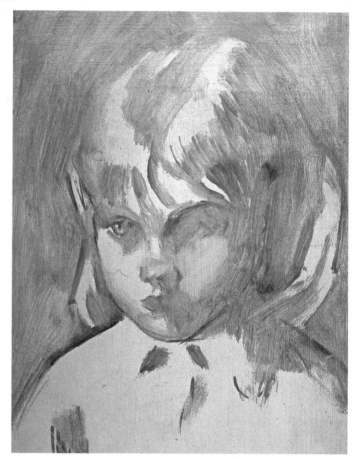

Step 1. Begin the grisaille. *Working on an un-toned board, I use yellow ochre mixed with white and diluted with turpentine to lay in thin washes designed to indicate the form of the head and figure, and to suggest some of the tonal balance.*

Step 2. Refine the grisaille. *With the same yellow ochre-white mixture, I cover all but the white areas, which are shown by the white gesso priming of the board.*

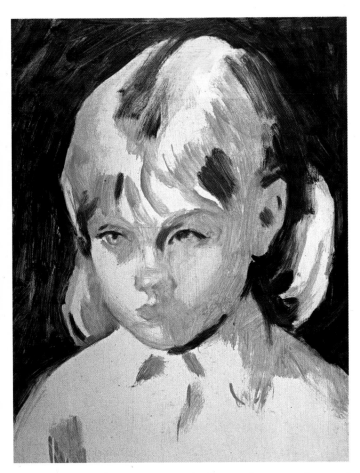

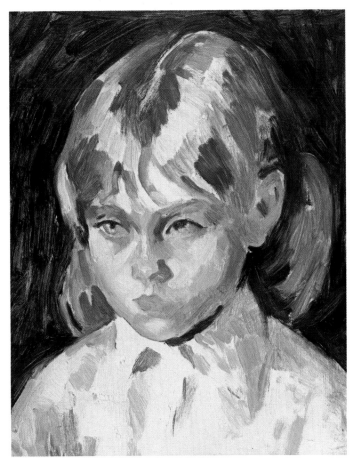

Step 3. Block in the darks. *With raw umber and burnt sienna, I block in all the darks. I now have an underlying foundation of a three-value outline upon which I can proceed to paint in full color.*

Step 4. Begin work in full color. *I begin with the halftone or transitional areas. My basic colors are still yellow ochre and white with additions of terra rosa for the warm, reddish accents in the skin. This same mixture plus additional white is used for the light areas, which are now covered for the first time. White and cadmium scarlet are used to spot in the middle tones on the white blouse.*

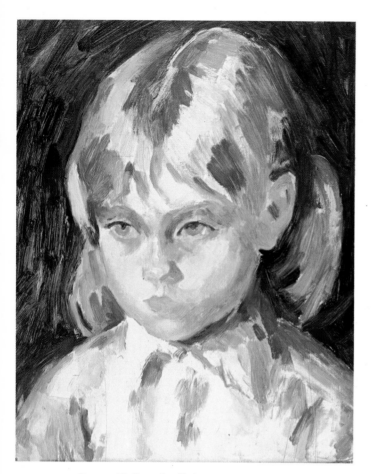

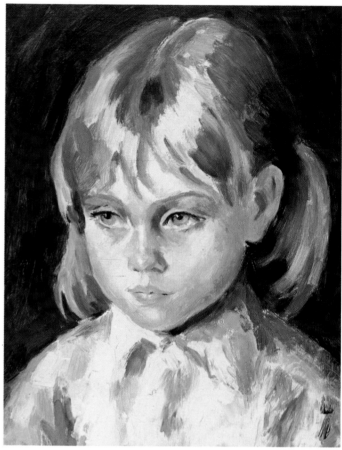

Step 5. Refine the light areas. *I now concentrate on the light areas throughout the painting. Naples yellow and white are applied to the face; yellow ochre, cadmium yellow pale, and white to the hair; cadmium yellow pale and white and touches of cobalt blue to the blouse.*

Step 6. Adjust the color temperature. *Wherever I see cools—such as in and around the eyes, within the shadow of the blouse, and so forth—I add touches of cobalt blue. Then I gently pass the palette knife over the entire painting to blend all the elements together slightly. I warm the color on the ear and deepen the shadow area on the hair and the colors in the background. I also define the features more carefully.*

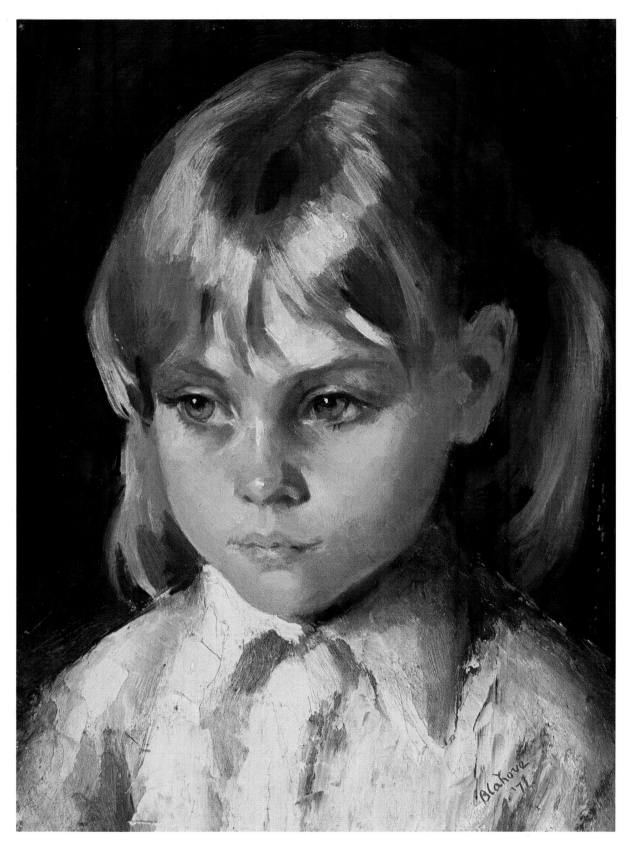

Cindy. *Oil on board, 10″ x 8″ (25.4 x 20.3cm). Collection of the artist. I now concentrate on the dark areas, strengthening them where necessary and elaborating the transitional areas lying between the dark and medium tones. Such details as the eyes, the shape of the nose, and the slash between the lips are worked on and the warm tones of the skin are added. As a final touch, I place a few highlights, particularly the catchlights, within the pupils.*

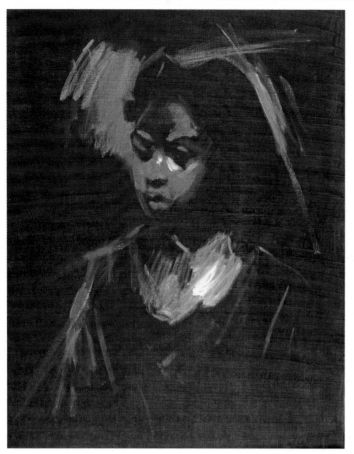

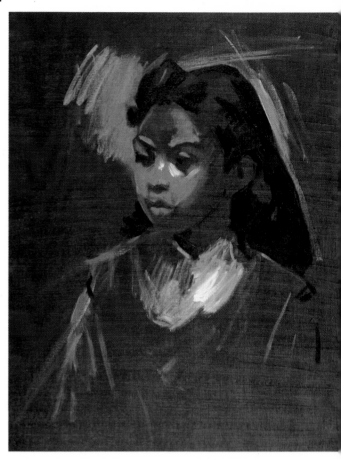

Step 1. Block in the lights. *Over a previously dark-toned board, 20″ x 16″ (50.8 x 40.6cm), I block in the light areas in the head, blouse, and part of the background with a mixture of yellow ochre, cadmium scarlet, cerulean blue (for the cool aspects of black skin in light areas), plus white, all thinned with turpentine. I plan to use the umber tone of the board as the medium value in the picture.*

Step 2. Add the darks. *I lay in the darks with a combination of raw umber, alizarin crimson, and cobalt blue. I am following the procedure I use when beginning with a medium tone— working out toward the lights and the darks.*

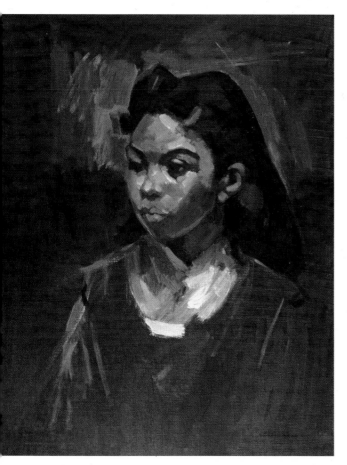 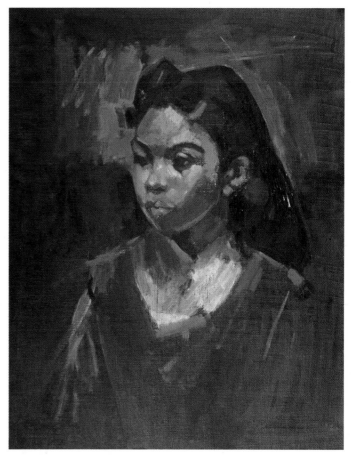

Step 3. Detail the lights and model the middle-tones. *The light areas of the face and background are now worked out in greater detail. I perform the modeling within the medium-toned areas of the head, which were bare until now. Yellow ochre, Naples yellow, cadmium scarlet, raw umber, and white are my colors.*

Step 4. Add the cool tones. *I place the appropriate cool notes. Then the entire painting is scraped with the palette knife to help unite and fuse all the elements.*

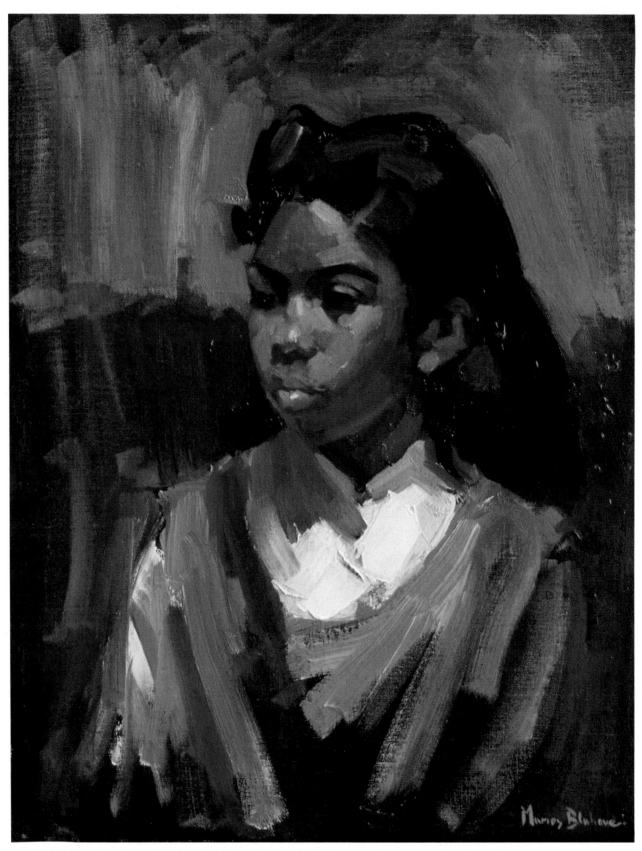

Patricia. *Oil on board, 20″ x 16″ (50.8 x 40.6cm). Collection of the artist. I go over the entire painting, applying bold strokes where necessary and adjusting colors, values, and shapes. Dense strokes of white are applied with the palette knife to such areas as the blouse and the sleeve. Highlights are placed on the forehead, nose, and lower lip.*

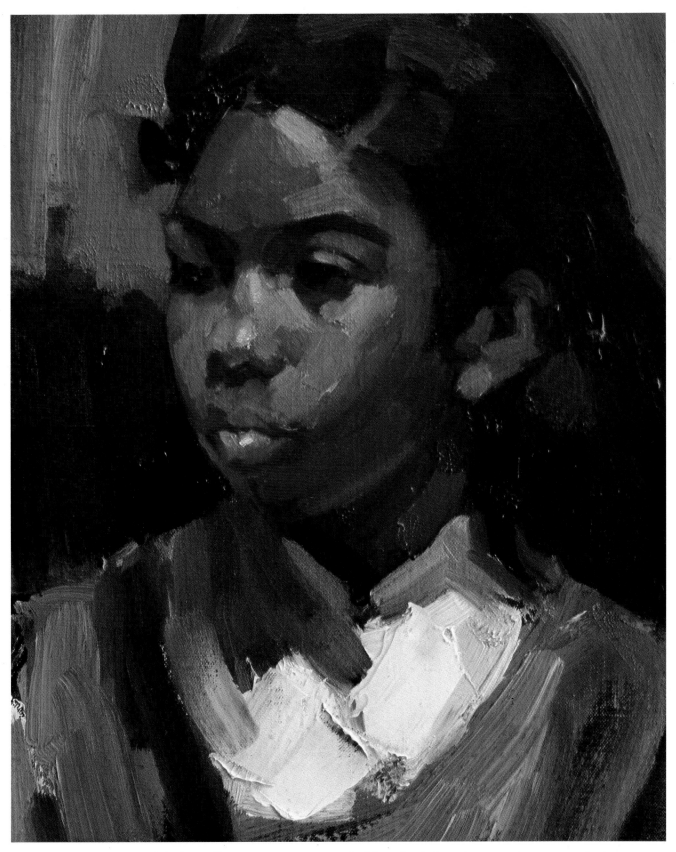

Patricia *(Detail). Here you can see my bold method of applying strokes, particularly in the blouse where the impasto is quite thick. The entire painting was executed in a single sitting lasting perhaps one and a half hours, and the blocky, plastic effect is the result of my swift, direct technique. The dark board also helped speed the painting process.*

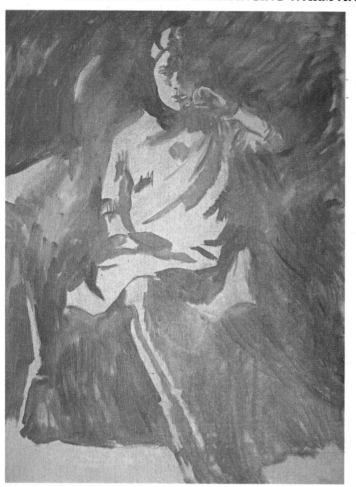

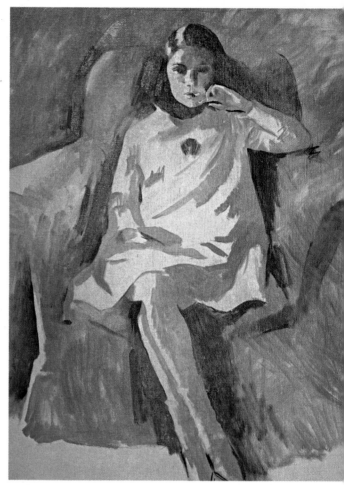

Step 1. Begin the grisaille. *Over a previously executed charcoal outline (see page 108), working on a canvas 26" x 20" (66 x 50.8cm), I use cerulean blue, white, and a touch of yellow ochre to cover all the areas on the canvas except for the lightest ones. Although I sometimes fix the charcoal drawing first, this time I merely blow off the excess charcoal and paint right over it with oil.*

Step 2. Add the darks. *I now proceed to lay in all the darks, paying particular attention to where the lightest and darkest values come together to form the sharpest edges. Where the conjunction of values is less pronounced, such as in the shadow of the face against the hair, the edges are softened by blending.*

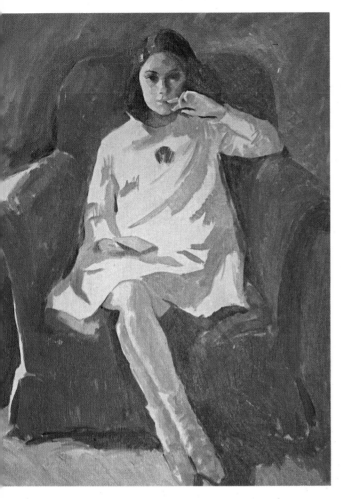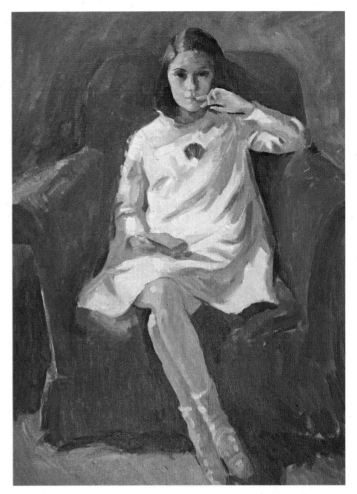

Step 3. Add the middle tones. *I now call in the model and concentrate on the middle tones, which I separate into two categories—the lighter and the darker ones. Some of the darks, such as the neck and the areas surrounding the legs, are relegated to dark halftone instead of shadow areas. The background is grayed down and the blue of the chair is emphasized.*

Step 4. Add the lights and adjust tones and colors. *The light areas, which until now have been left blank, are filled in. At the same time, those areas lying next to the lights, such as those in the dress, are adjusted in value and color.*

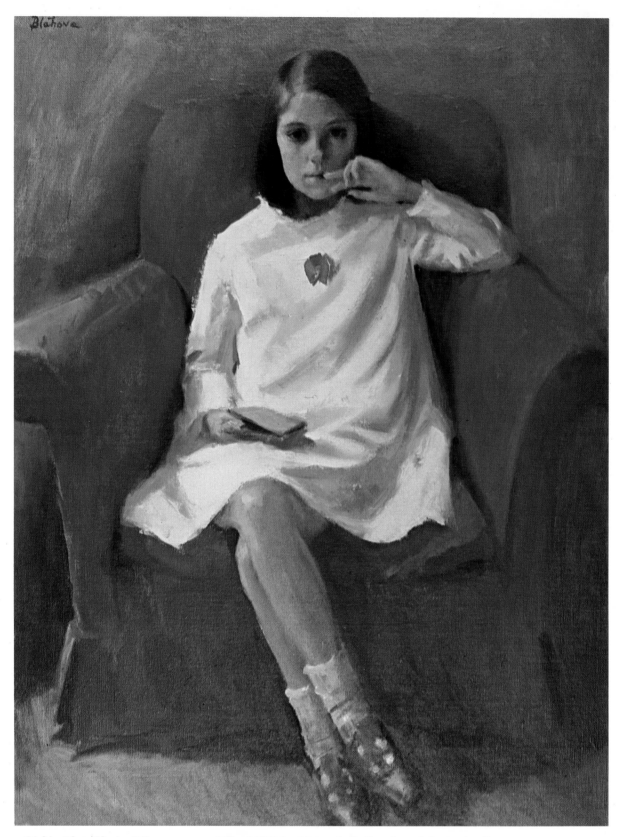

Girl in Blue Chair. *Oil on canvas, 26″ x 20″ (66 x 50.8cm). Collection of the artist. I carefully evaluate the color of the darks and lights. Where necessary, I blend the darker halftones with finger, fan blender, and palette knife to soften them. A bright red note is introduced in the dress. Working from dark to light in this instance, I adjust shapes and colors and blend together areas of equal value. Except for the tones of the skin, bow, book, and shoes, cool colors strongly predominate.*

CHAPTER TEN

Handling the Brush and Knife

An artist can be a conceptual genius and, at the same time, a physical dud. Unless he manages to coordinate these two functions, his value to art is minimal. To successfully wed them, he must place as much of an emphasis on the *craft* of painting as on the *art* of painting, since one is useless without the other.

In art, as in every line of work, you must first learn how to use the tools of your trade before you can make a meaningful contribution to it. Here, the brush and the knife are your tools. They must be thought of as extensions of your fingers that take direction from your mind and eye through the act of transforming creative dictates into physical results.

USEFUL TIPS
Here is some practical advice on how to use the tools of your trade:

Always lay out lots of color on the palette. Do not stint on the paint—it is relatively cheap when you weigh its monetary value against the artistic value of the painting.

Load your brush with lots of paint. It is better to lay in too much paint than not enough—the excess can always be scraped away with a knife or wiped out with turpentine.

Be free with a loaded brush. Do not be afraid to make mistakes. Instead, guard against timidity. This is the painter's real enemy.

Use the knife for at least fifty percent of the painting. The knife teaches you to place your strokes boldly and to avoid a picky, overly fussy technique. Exactness is not conducive to oil painting.

Blend with your knife. Blending or fusing your strokes with the knife produces very exciting and striking transitions of color. Fussing in these areas with small brushes robs the painting of much of its zest.

Paint your lights thick and your shadows thin. This is in accord with the Old

Master approach and is one to which I subscribe. Your light areas are the most important and therefore deserve the greater focus and attention as to color, degree of finish, and impasto.

Vary your brushstrokes. Just as you balance your warms against your cools, vary the density of your brushstrokes. Thick paint next to thin is more visually intriguing than a completely slick or a completely rough canvas. An uneven surface texture is very desirable in an oil painting.

COMMENTS ABOUT EDGES

Although there are no lines (edges) in nature, they do exist in the imagination, and the imagination is your most valuable guide in painting a picture. Where the lightest light meets the darkest dark, the hardest edge seems to occur. This also holds true in those areas where skintone meets costume or background, but *not within the face itself*, since skin color never really goes all that dark. Conversely, two *similar* values coming together tend to produce the softest edge.

I always make it a point to light my subjects in such a way that somewhere within the painting at least some hard edges are formed by the juxtaposition of two deeply contrasting values. I then emphasize these edges and use them as focal points of the painting.

Use your knife to show a hard edge or two somewhere in the painting. It is ideally suited for this purpose and produces a truly distinctive and arresting edge.

Penny *(Detail, Right). Oil on board, 24″ x 20″ (61 x 50.8cm). Collection of Mr. and Mrs. Henry St. John FitzGerald. I paint the lights thickly and the darks thinly. In such areas as the shirt, the edge of the hat brim, the hat crown, and in several of the highlights in the face and hair, the mark of my palette knife is clearly evident. The variety in surface texture makes a painting interesting.*

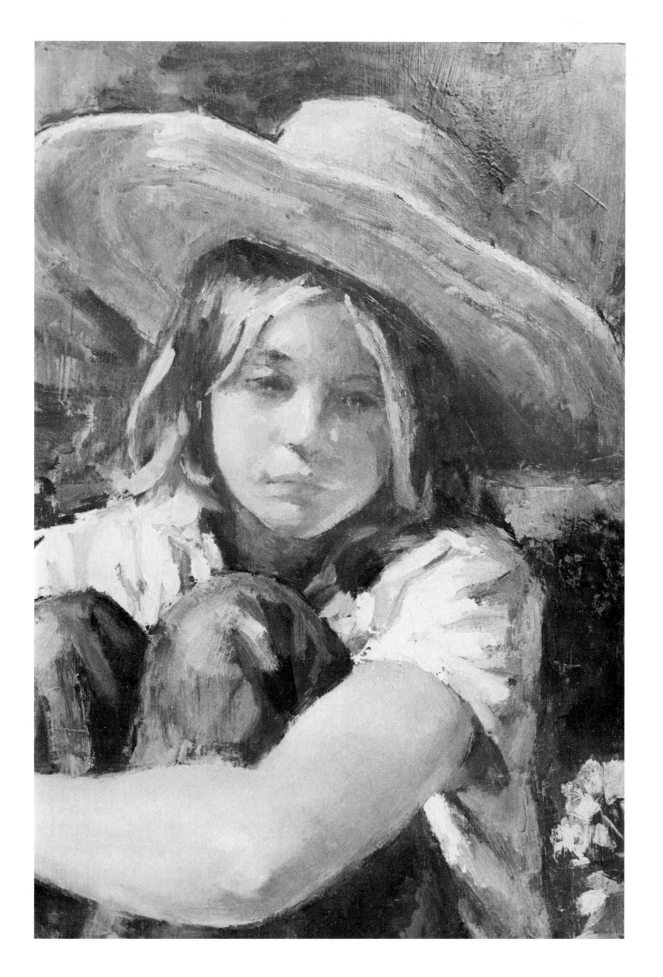

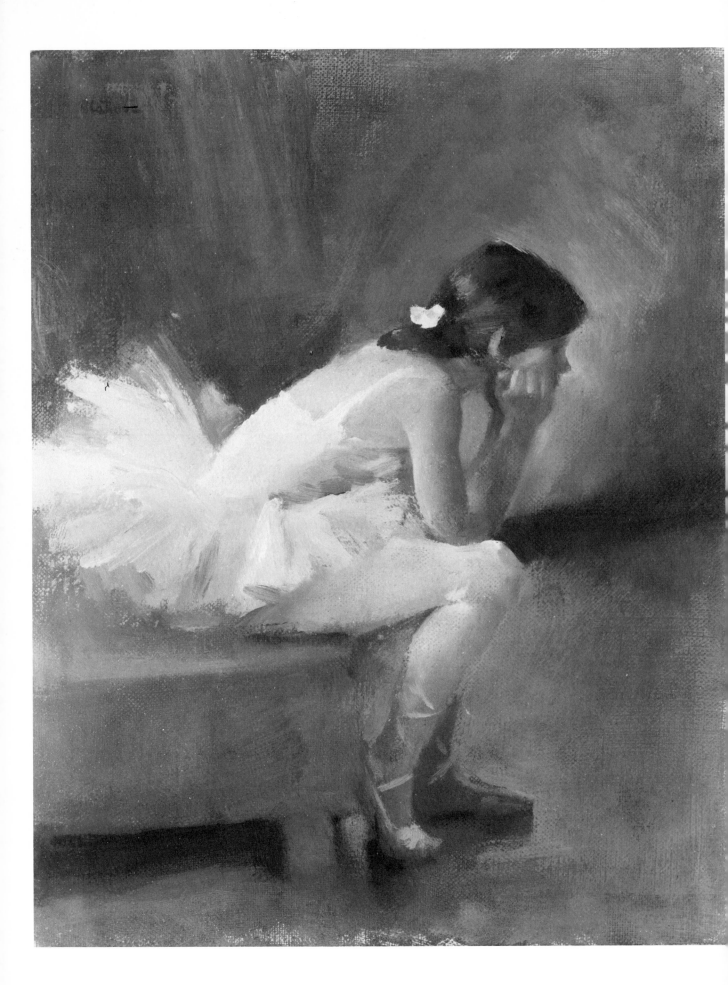

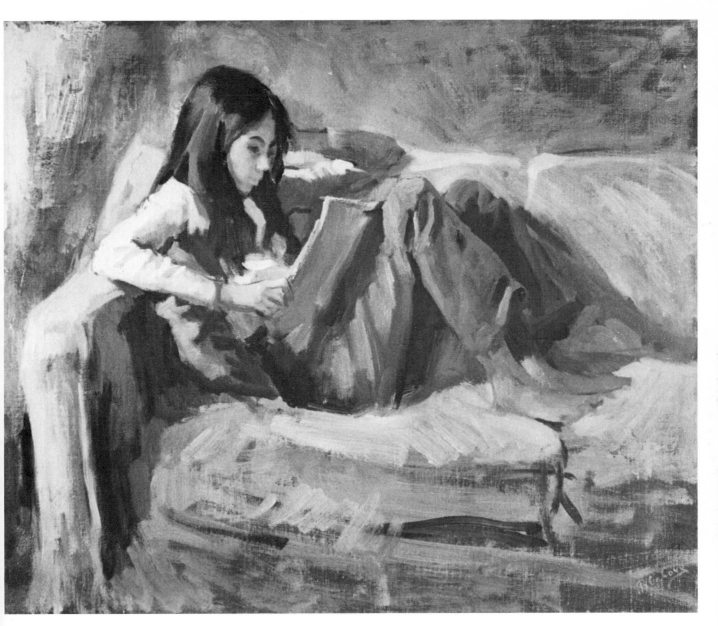

Seated Ballerina *(Left). Oil on canvas, 10" x 8" (25.4 x 20.3cm). Private collection. This painting shows how I blend those areas where equal values meet, as, for instance, the lower legs—which are almost matching in value with the floor; the seat as it rests on the model stand; and the forearms as seen against the wall. However, where a highlight comes up against a dark—such as in the ballerinas's back, her hair ribbon, and the top of her knee—hard edges are formed.*

Pamela Reading *(Above). Oil on canvas, 16" x 20" (40.6 x 50.8cm). Collection of Dr. and Mrs. William J. Gazale. This picture is painted in strong, distinct strokes. I have made little effort to blend them, so they stand out in bold relief. Often, the strokes follow the form, as, for instance, those on the model's right thigh. The brushstrokes on the pillows and the sofa are equally evident. (The finished painting appears in color on page 69.)*

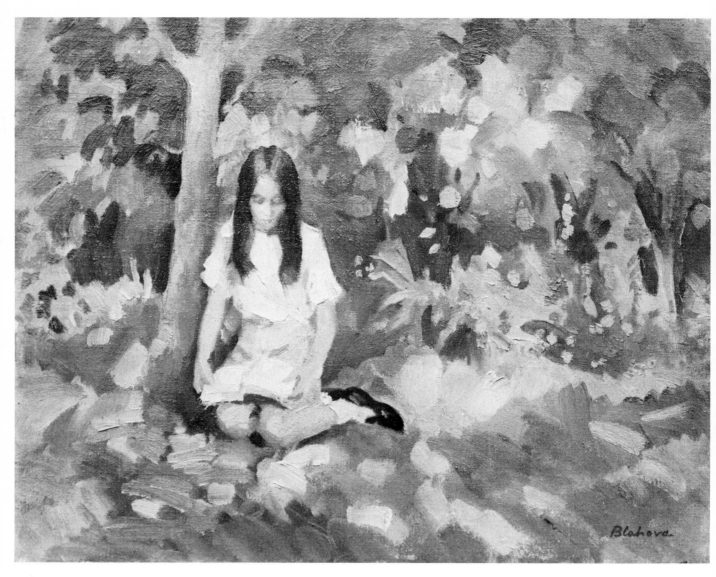

Girl in Landscape (Above). Oil on canvas, 16″ x 12″ (40.6 x 30.5cm). Collection of the artist. I painted this on location in a dappled kind of light which I tried to represent with crisp, distinct brush and knife strokes. Note particularly the texture of the light brushstrokes, some of which hold a good deal of paint and present a surface of considerable impasto. I advise my students to load their brushes heavily and lay on the paint freely and with some abandon. Too much paint is better than not enough.

Pam (Right). Oil on masonite, 10″ x 8″ (25.4 x 20.3cm). Collection of Marion Kreisman. Because I paint in big forms and add little detail, this small study in which the figure is only four inches (10.2cm) high, had to be depicted in just a few broad strokes. I believe that by carefully placing my major lights and darks with a big brush, I managed to attain quickly the semblance of reality. The careful painter using tiny strokes of a small brush, might take days or weeks to arrive at the same statement.

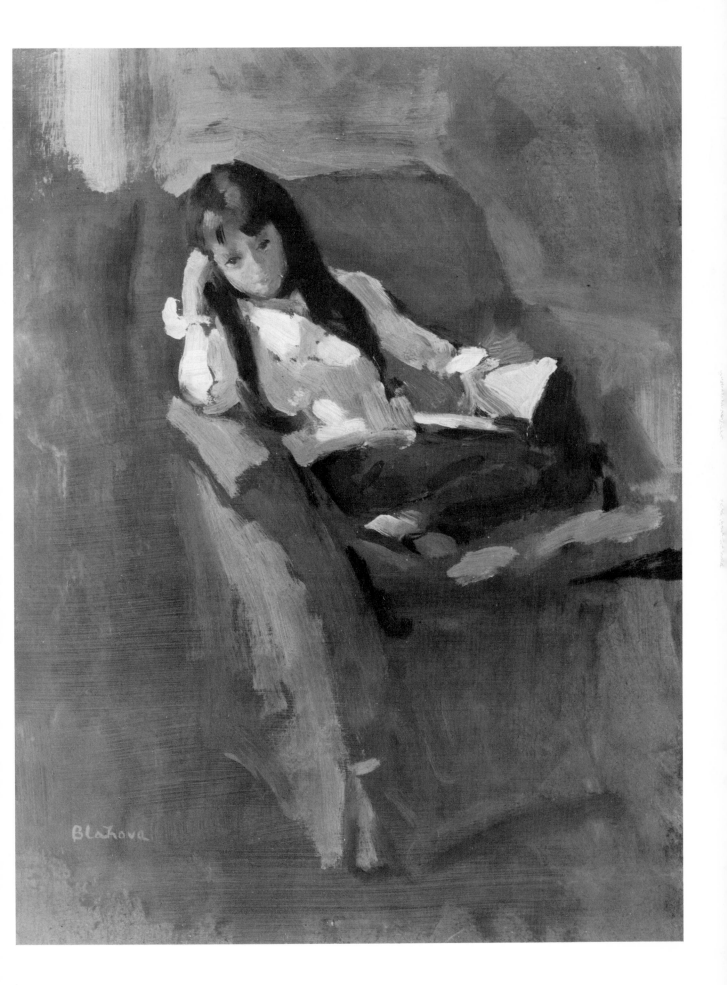

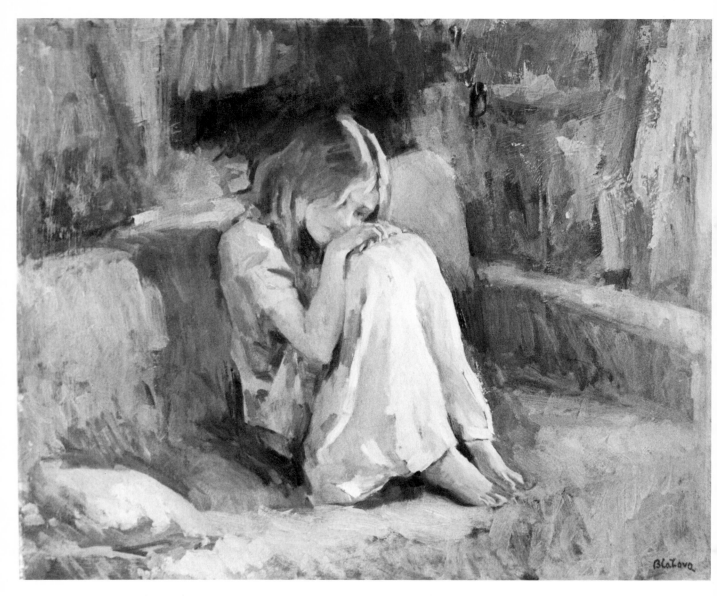

Pensive Girl. *Oil on board, 16" x 20" (40.6 x 50.8cm). Collection of the artist. If you confine the more careful brushwork to the subject and use bold, loose strokes on the rest of the painting, the tight brushwork acts like the lens in a camera, focusing on the important aspect of the subject matter and blurring the other elements. Actually, our own vision works on this same principle. If you show all the areas of the painting in equal detail, the eye grows quickly tired, not knowing where to look first.*

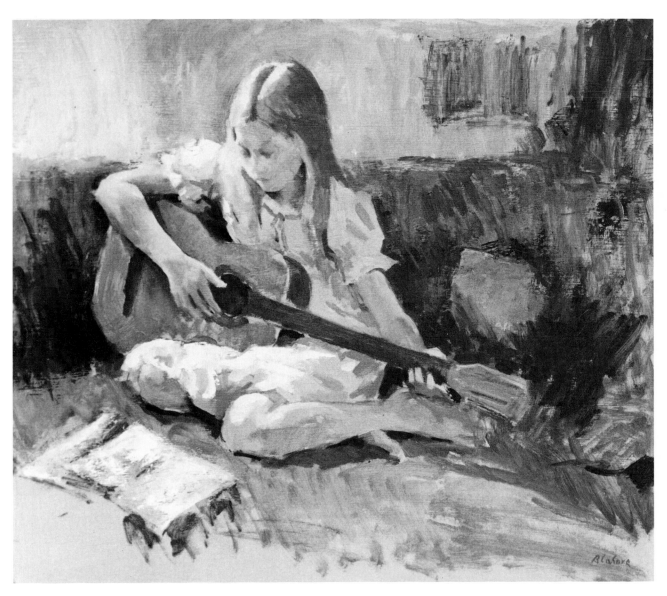

Music Lesson. *Oil on masonite, 20″ x 24″ (50.8 x 61cm). Collection of the artist. Note the brushwork in the sofa and background. It is rough, extremely free, and apparently unfinished. The bare board is exposed in some thinly painted areas, while in others, the paint is laid in thickly. This is my approach to backgrounds. Rather than fill them in with paint from border to border, I prefer to see them as masses of color and value whose purpose is not to show specific objects but to enhance the subject, which is most important.*

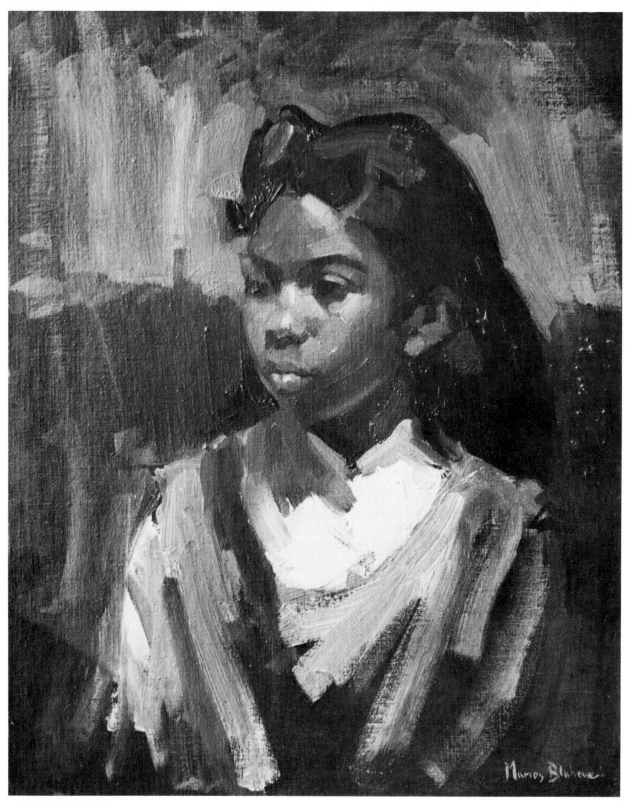

Patricia. *Oil on board, 20″ x 16″ (50.8 x 40.6cm). Collection of the artist. I painted the head in blocky, loaded strokes designed to produce distinct planes and to lend a solid, sculptural feeling to the form. The opposite approach would have been to blend all the strokes together, smooth out the texture, and aim for a more subtle effect by gently rounding off the form. The direct painting method I advocate inclines you to the first approach. (The finished painting and a detail appears in color on pages 132 and 133.)*

Patricia *(Detail). Here you can see the impasto strokes in the dress. They were put down swiftly with a heavily charged brush and, once down, were not gone over again. If you can make your statement with one distinct stroke, why bother with additional ones? Speedy execution allows you to work in a kind of fervor of artistic inspiration. It is better to make a bold mistake than to fuss and noodle excessively in timid indecision.*

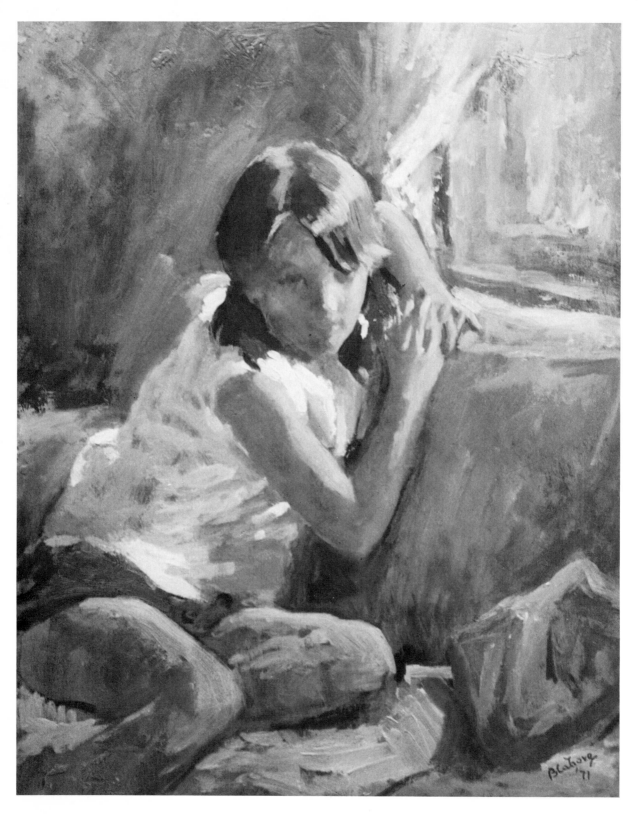

Beth. *Oil on masonite panel, 16″ x 12″ (40.6 x 30.5cm). Collection of the artist. For those who worry about features, this would represent a capital failure. Nowhere are the eyes, nose, and mouth outlined or delineated—they are merely aspects of light, halftone, and shadow. But you are not painting individual features; you are portraying form as bathed by light. So despite the apparent lack of precision, you can achieve a likeness if you set down the patterns of lights and darks simply and accurately.*

Bibliography

Dunstan, Bernard. *Composing Your Paintings.* New York: Watson-Guptill, 1971. London: Studio-Vista, 1971.

——, *Painting Methods of the Impressionists.* New York: Watson-Guptill, 1976. London: Pitman, 1976.

——. *Paintings in Progress.* New York: Watson-Guptill, 1976. London: Pitman, 1976.

Mayer, Ralph. *The Artist's Handbook of Materials and Techniques.* 3rd rev. ed. New York: Viking, 1970.

Renoir, Jean. *Renoir, My Father.* London: Collins, 1962.

Singer, Joe. *How to Paint Figures in Pastel.* New York: Watson-Guptill, 1976. London: Pitman, 1976.

——. *How to Paint Portraits in Pastel.* New York: Watson-Guptill, 1972. London: Pitman, 1972.

——. *Painting Men's Portraits.* New York: Watson-Guptill, 1977. London: Pitman, 1977.

——. *Painting Women's Portraits.* New York: Watson-Guptill, 1977. London: Pitman, 1977.

Index

(Note: Names of paintings appear in *italics*.)

Edited by Bonnie Silverstein
Designed by Bob Fillie
Set in 11-point Melior